WOMEN AND BEAUTY
IN POMPEII

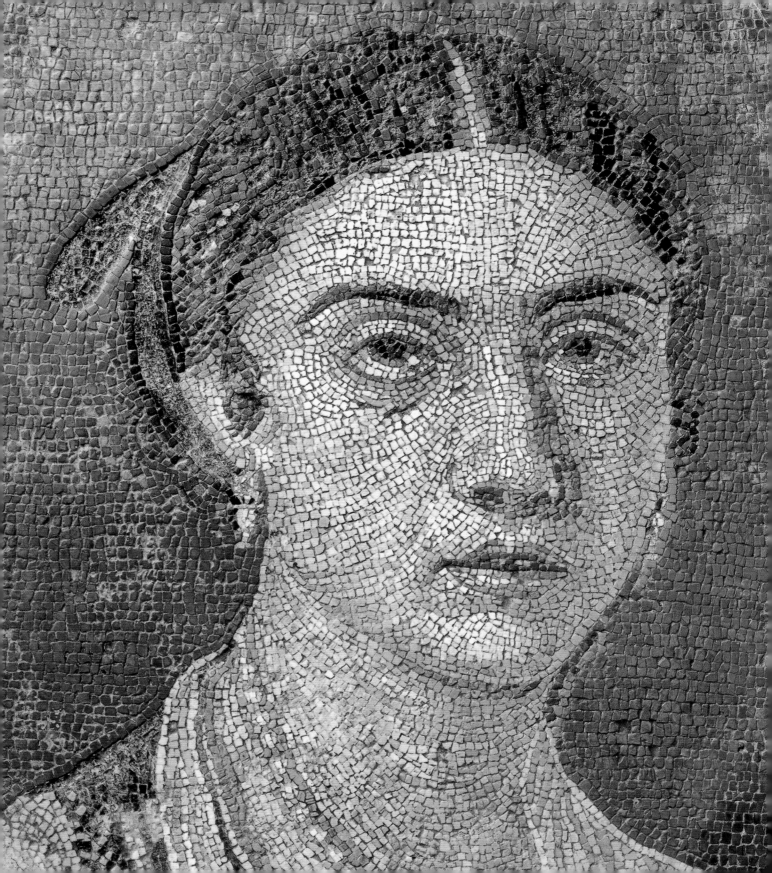

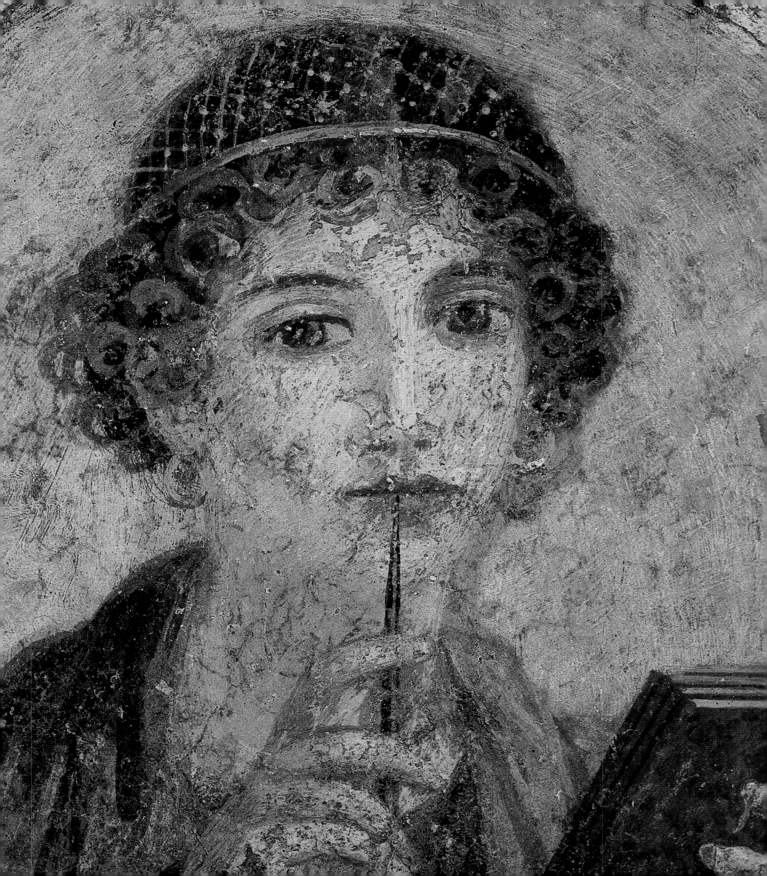

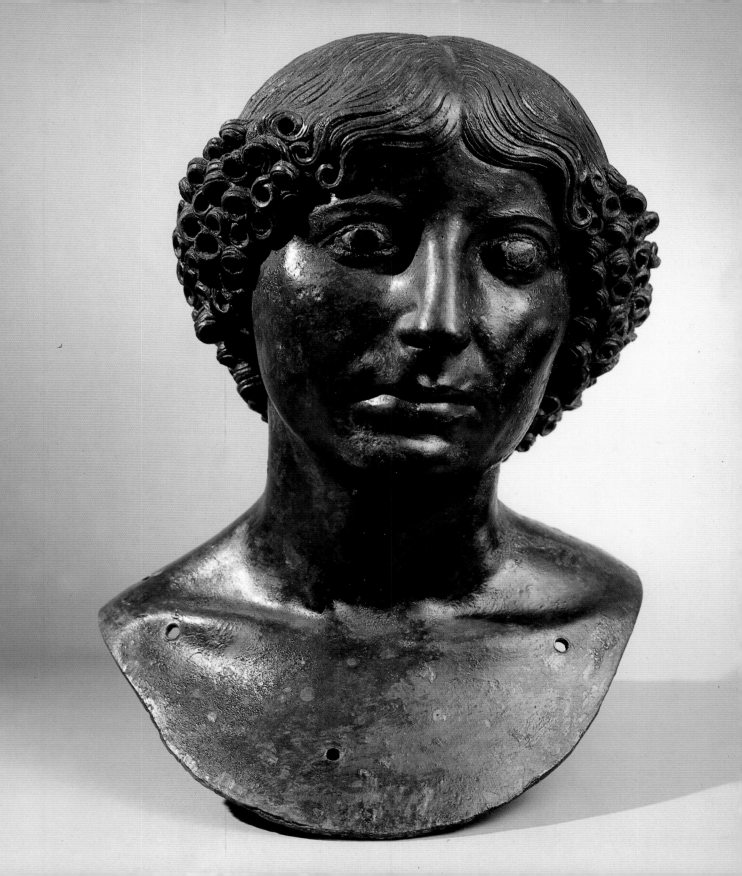

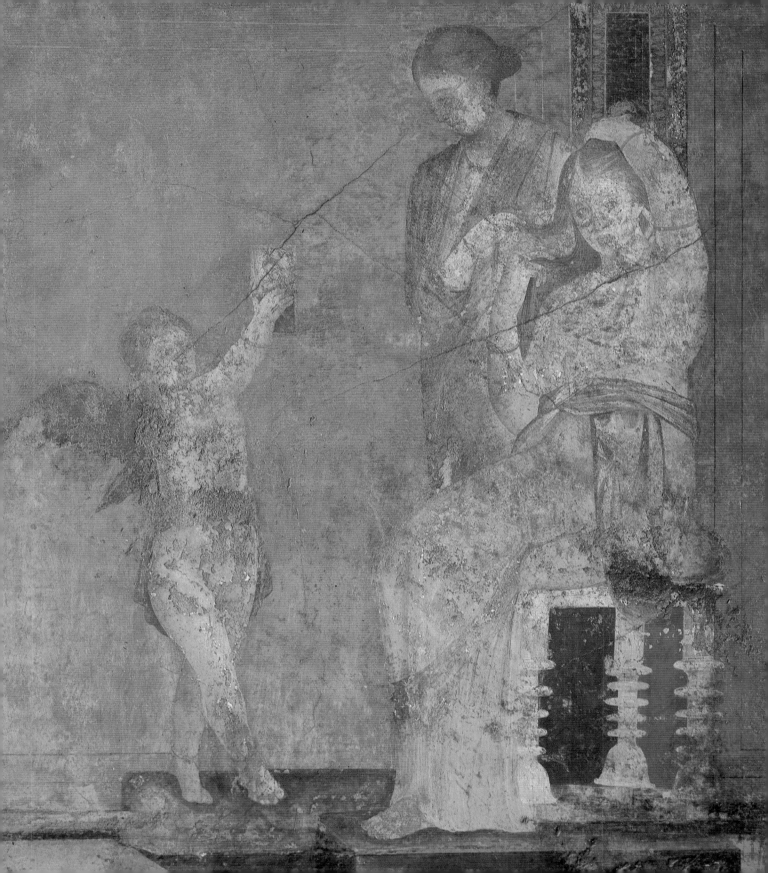

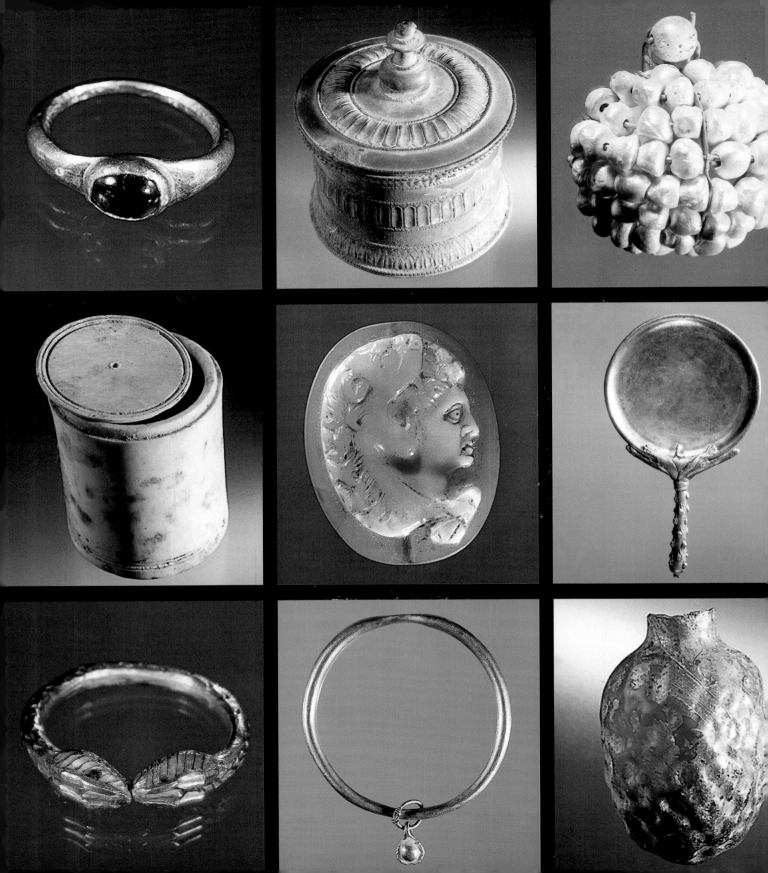

Antonio d'Ambrosio

WOMEN AND BEAUTY IN POMPEII

The J. Paul Getty Museum • Los Angeles

Antonio d'Ambrosio

Women and Beauty in Pompeii

Translated by Graham Sells

First published in the United States of America in 2001 by
The J. Paul Getty Museum
1200 Getty Center Drive, Suite 1000
Los Angeles, California 90049-1687
www.getty.edu/publications

At the J. Paul Getty Museum

Christopher Hudson, *Publisher*
Mark Greenberg, *Managing Editor*

Library of Congress Catalog Card Number 2001091030

ISBN 0-89236-631-1

Printed in Italy

On the cover:
Painting of a woman looking in the mirror. From the Villa di Arianna, Stabiae (first century A.D.). Naples,
Museo Archeologico Nazionale.

Photographs:
Alfredo and Pio Foglia, Naples

CONTENTS

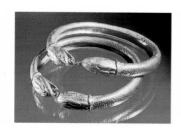

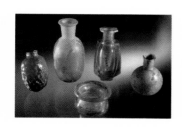

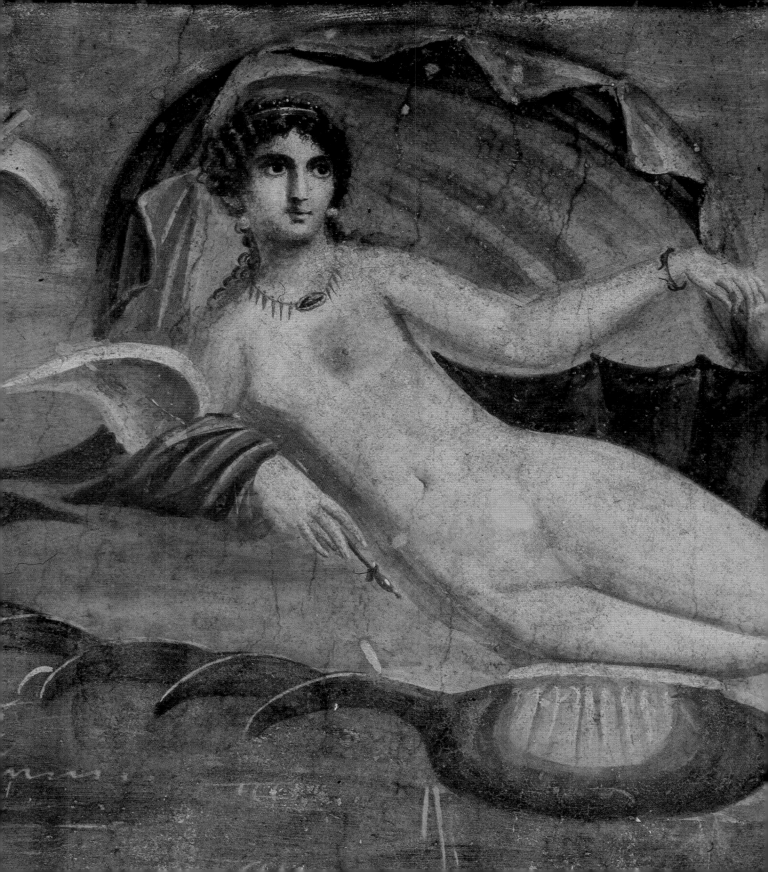

INTRODUCTION

One of the episodes in the celebrated fresco that gives its name to the Villa of the Mysteries at Pompeii shows a woman, possibly preparing for her wedding, seated on a stool while a maidservant arranges her hair. Two cupids look on, one holding a mirror toward the woman, who gazes into it.

Taught and encouraged by some, censured by the moralists, often lampooned by the satirical poets, the cultivation of beauty was, then as now, a woman's constant goal, to be achieved by any means possible. Creams, lipsticks, and bangles were employed for the purpose, at times in such wild excess as to surpass every limit of good taste, as certain sources tell us.

This small volume offers a brief overview of the most common forms of beauty treatments, methods, makeup, and jewelry that the women of Pompeii (and, more generally, of the Roman world in the first century A.D.) employed in order to enhance their appeal. Much of the information has been gleaned from records left by the authors of the period, and its veracity is in many cases borne out by archaeological evidence from Pompeii and other cities in the area. When Mount Vesuvius erupted in August of A.D. 79, it buried Pompeii, Herculaneum, Stabiae, and the surrounding countryside under a pall of ash and lapilli more than 5 meters deep. Life was suddenly interrupted and never resumed, leaving the urban landscape, houses, decoration, furnishings, and everyday objects unaltered. To this tragic event we owe the extraordinary amount of evidence preserved in the cities, villas, and farms of the region.

Here we shall be looking above all at everyday objects associated with health, hygiene, and beauty. Where possible, we will associate the objects with records from ancient sources so that the written accounts and concrete evidence may enhance one another.

Fresco. Casa di Venere in conchiglia, Pompeii.

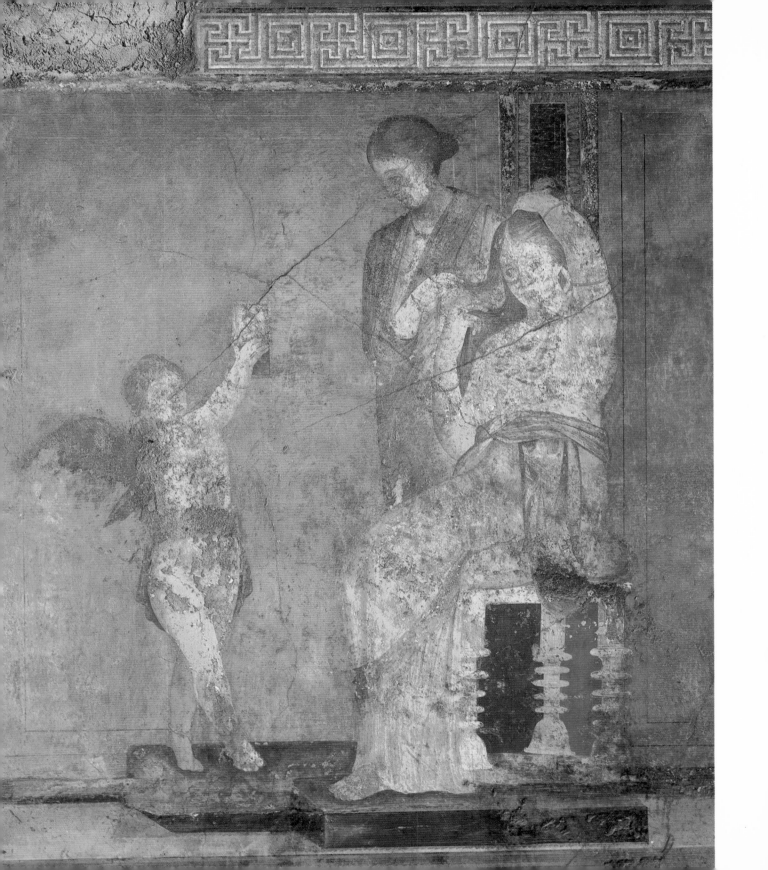

BODY CARE

Personal Hygiene

A primary aspect of body care is, of course, the business of keeping clean and avoiding body odor. In fact, one of the first recommendations the poet Ovid makes to women in his *Art of Love* is "do not let your armpits reek like a goat . . . do not let your teeth turn black through laziness . . . but wash out your mouth every morning" (III.193–199). So, one of the first things to see to every day was washing—at least the arms, legs, and face. A complete bath, as far as we can tell from Seneca (*Epistles* 86.12), was carried out once a week, or every nine days, on market day. A point to bear in mind is that at Pompeii, and probably at Rome and elsewhere, only the houses of the richest residents

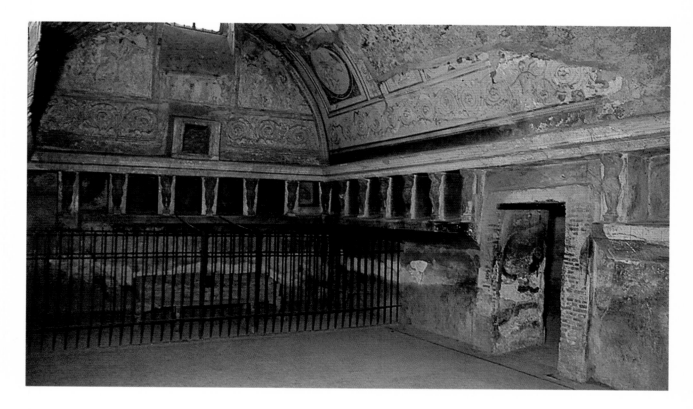

Painting of the toilet of the *domina*. Villa dei Misteri, Pompeii.

***Tepidarium* in the Forum Baths,** Pompeii.

DO NOT LET YOUR ARMPITS REEK LIKE A GOAT . . . DO NOT LET YOUR TEETH TURN BLACK THROUGH LAZINESS . . . BUT WASH OUT YOUR MOUTH EVERY MORNING.
OVID, *ART OF LOVE* III.193–199

were equipped with rooms for baths and a complete wash; most people were obliged to go to the public baths. The baths at Pompeii (the Forum Baths and the Stabian Baths) included a section for women, but we also have evidence that mixed bathing was customary, at least in Rome. Moreover, the new baths that were being built in Pompeii itself when the eruption occurred did not include separate sections for men and women.

Washing was performed with a sponge and abrasive products combining powders and creams. Obtained mostly from mineral and vegetable substances, the various products included such items as *creta fullonica*, a clay product; *lomentum*, a preparation based on a flour made with broad beans and dried, crushed snail's shells; *struthium*, or soapwort root; and *nitrum*, an ash lye. Some Romans went as far as rubbing pumice stone on their skin to cleanse it and smooth it at the same time. With such rasping systems, an indispensable stage after washing must have been the application of ointments on the irritated skin, to soothe it and restore its softness.

Ears were cleaned using *auriscalpia*, slender sticks with a tiny disk at one end; these were usually fashioned from bone, ivory, or bronze. As for the teeth, they were normally cleaned with soda and bicarbonate, or with pumice-stone powder. And—bizarre as it may seem—they were also cleaned with urine, according to the accounts of a number of authors, including Pliny the Elder (*Natural History* XXVIII), Cato (*On Agriculture* XXXIX), and Catullus (*Poems* 39.23-25). After meals, diners would attempt to remove the fragments of food left between their teeth with a tool called a *dentiscalpium*, which consisted of a small

Auriscalpium **and tweezers for cosmetic use.** Pompeii.

Mirror in cast silver (see p. 29, fig. 20). Terzigno.

stick of metal, bone, or wood ending in a hook. "The best is from the mastic tree, but if you have no pointed wood you can take care of your teeth with a quill" (Martial, Epigrams, *Apophoreta*, 22). Both *dentiscalpium* and *auriscalpium* might be combined in one tool, consisting of a stick with a hook at one end and a small disk at the other.

Lozenges were used to perfume the breath, although not, apparently, always with the efficacy that might be desired: "To avoid stinking too much of the wine you drank yesterday, Fescennia, gorge yourself on the tablets from Cosmo's perfumery. These preparations plaster the teeth, but they are no use when a belch rises from the depths" (Martial, *Epigrams* I.87).

Beauty Treatment

Once washing and cleansing were over, one of the first and most important operations to improve the body's appearance must have been hair removal, as suggested by various authors: "Do not let bristly hair make your legs rough!" warns Ovid (*Art of Love* III.194). To this end, Roman women used depilatory creams (generically called

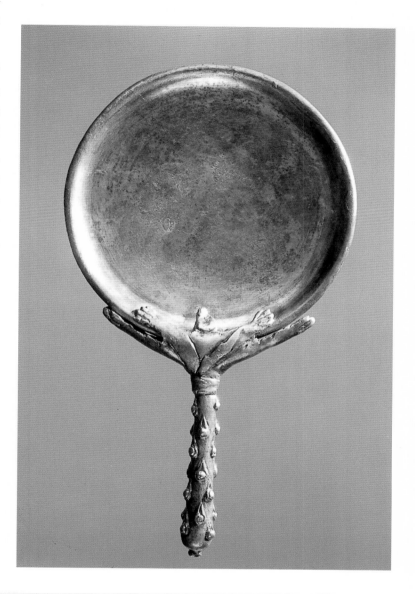

AND IF THE FACE LACKS THE NATURAL ROSY HUE THAT COMES FROM THE BLOOD, THERE ARE ARTS TO ACHIEVE IT. APPLY YOUR ART TO REINFORCE THE THIN RIM OF THE EYEBROWS, AND LET A SMALL MOLE ADORN THE MILKY-WHITE CHEEKS. NOR IS THERE ANY SHAME IN HIGHLIGHTING THE EYES WITH FINE CHARCOAL OR WITH CROCUS.
OVID, *ART OF LOVE* III.200–204

psilothrum) based on a solution of pitch in oil mixed with resin and wax, to which certain caustic substances were added, not unlike the substances used in modern waxing. Apart from the creams, tweezers similar to the type now used for eyebrows were commonly employed in Roman times. Made mostly of bronze, although they might also be silver or gold, tweezers were originally used to remove hair from the armpits—there was even a slave known as the *alipilus* whose particular task was to perform this function.

Skin care—softening the epidermis, lightening blotches, and achieving a milky-white hue—was accomplished using a series of masks, referred to by various authors, often disapprovingly. Efforts to "make herself beautiful" might be taken to denote a loose woman after adulterous adventures. Juvenal offers a good example: "Often her face . . . is swollen with breadcrumbs and gives off the stench of Poppea's creams, and this is the mess her poor husband's lips are caught in, but her face is freshly washed when she goes to her lover! . . . But that face, transformed and softened with endless poultices, plastered with endless cakes of flour, cooked, and soaked, would you call it a face or a sore?" (*Satires*, VI.461–473).

Such was Juvenal's biting comment; Ovid offers very different tone and intentions in his *Medicamina faciei feminae* (*Cosmetics for Women*). He recommends a great many beauty masks, generally of plant origin (barley, honey, broad beans), made fragrant with essence of roses or myrrh, although there are also such unusual substances as deer horn and halcyon (kingfisher) excrement. For example, the secret of a smooth skin is a cream made with barley, eggs, ground deer horn, narcissus bulbs, resin, and honey. For a milky-white skin free of blotches, on the other hand, the right preparation was made with lupines and broad beans toasted and ground, with the addition of white lead, saltpeter foam, halcyon guano, and, finally, honey as the amalgamator.

Another rich source of cosmetic counselling is Pliny's *Natural History:* Ass's milk will smooth out wrinkles and make the skin soft and white; butter blended with white lead is effective against acne; calf genitals cooked with honey and vinegar until a gluey cream forms is excellent for dermatitis; a solution of bile from a bull or ass mixed with water is effective against blotches on the face. Of great utility in protecting and softening the skin are honey and swan fat, which also smoothes out wrinkles (although goose or hen fat will also do so, and are usually more handy).

LEST YOUR HAIR DRENCHED IN OINTMENTS SHOULD STAIN YOUR FINE
SILK DRESSES, PASS A LARGE PIN THROUGH THE BRAIDED LOCKS
TO SUSTAIN THEM.
MARTIAL, *EPIGRAMS* XIV, *APOPHORETA*, 24

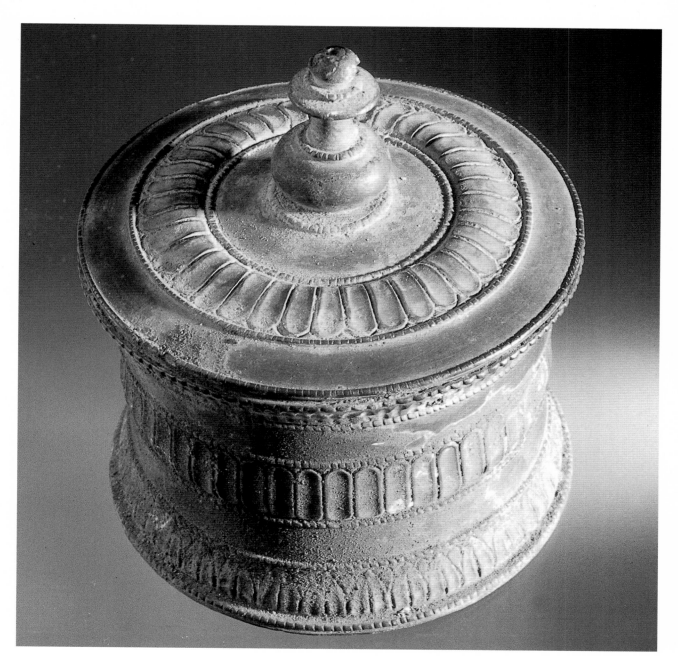

Cylindrical pyx in bronze (see p. 26, fig. 10). Pompeii.

Once these preliminary operations were completed, the next step was to apply the makeup itself. Again we turn to Ovid: "and if the face lacks the natural rosy hue that comes from the blood, there are arts to achieve it. Apply your art to reinforce the thin rim of the eyebrows, and let a small mole adorn the milky-white cheeks. Nor is there any shame in shading the eyes with fine charcoal or with crocus" (*Art of Love* III.200–204). Virtually all the ruses of makeup are concentrated here, from foundation cream to eye makeup—even the charming effect of a small mole. To bring a rosy hue to the cheeks, colorings such as wine dregs or red ocher were added to the whitening. As an eyeliner, simple smoke-black might do the trick, applied with the tip of a bone stiletto or hairpin. The finishing touch was, of course, a small mole and a spot of eye shadow made from powdered minerals such as malachite or azurite. If the situation should call for an even more stunning appearance, the face might be dusted with finely ground crystal or bloodstone to give it a suffused splendor. However, as Ovid shrewdly warns, a woman should absolutely never allow herself to be seen at her toilet or applying makeup, least of all by her lover: "Let not your lover catch you, however, with your jars of cream displayed on the table: a dissimulated art serves beauty all the better. Who would not be troubled by a face coated with scum, such a weight of it that it trickles down between the warm breasts? . . . Nor would I approve of applying mixtures of doe marrow in public, or scouring your teeth in front of everybody. These things procure beauty, but they are an ugly sight" (*Art of Love* III.209–218).

Let us now consider the receptacles and tools used to contain and apply makeup. We have already mentioned the bone stiletto, used just like today's eyebrow pencil.

Containers for powders and creams often took the form of a small cylindrical pyx made of bone or some other material. The product would be extracted from the vessels with spatulas or small spoons fashioned in various forms. These small utensils, made of bone, metal, or glass, were used to mix the creams. A particularly interesting find in this connection is the small beauty–case discovered at Oplontis in the Villa of Crassius Tertius, which also yielded an abundance of jewels. A small wooden case divided into compartments contained various glass ointment jars, bone spatulas, and small glass plates, upon which the creams were probably mixed.

LET NOT YOUR LOVER CATCH YOU, HOWEVER, WITH YOUR JARS OF CREAM DISPLAYED ON THE TABLE: A DISSIMULATED ART SERVES BEAUTY ALL THE BETTER. WHO WOULD NOT BE TROUBLED BY A FACE COATED WITH SCUM, SUCH A WEIGHT OF IT THAT IT TRICKLES DOWN BETWEEN THE WARM BREASTS?

OVID, *ART OF LOVE* III, 209–218

Another typical makeup container took the shape of a shell, usually a scallop shell, and was made of ivory, amber, or some such material.

Hairdressing

"Let not your hair be untidy: the action of the hands can give beauty or take it away. There is no single type of hairstyle: let every woman choose the one that suits her best after consulting her mirror. An elongated face calls for just one part, leaving the forehead free; . . . A round face needs the hair to be gathered in a bun above, leaving the ears uncovered. For another, the hair should be worn down, falling over both shoulders; . . . for another face the hair should be drawn back behind; . . . this one should wear her hair soft and puffy; that one straight and clinging; for yet another, it should be wavy like the waves of the sea. . . . Nor can I enumerate all the hairstyles; every day brings new ones." With this long list, Ovid (*Art of Love* III.133–152) describes a great variety of hairstyles worn in the Augustan era (27 B.C.–A.D.14). However,

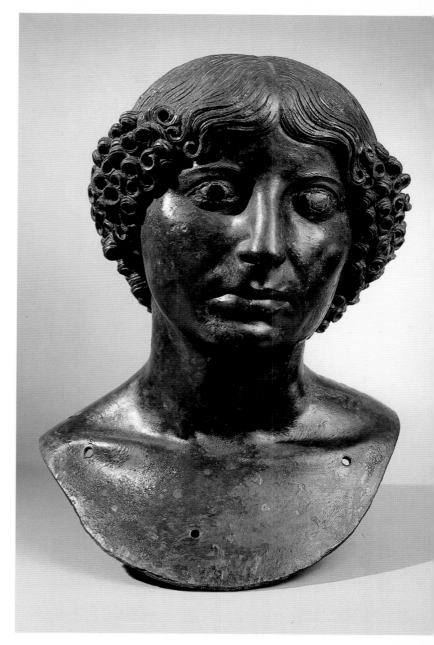

Female portrait in bronze (see p. 27, fig. 12). From Casa del Citarista, Pompeii. Museo Archeologico Nazionale, Naples, inv. 4990.

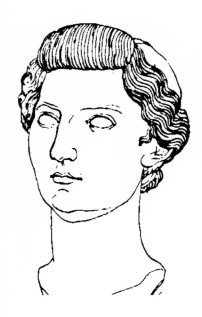

he seems to cover only simpler, everyday styles. Official portraits reveal other hairstyles worn during the same period that the poet failed to mention. For example, sculpted portraits of Octavia and Livia, respectively the younger sister and second wife of the emperor Augustus, show each woman wearing an elaborate hairstyle in which a large lock folds over the brow in a sort of pad, forming a plait that meets a bun at the back of the neck; two side locks curl softly over the temples and are then twisted back in the direction of the bun. A simplified version of this coiffure appears in various portraits of Livia sculpted between A.D. 10 and 20. The long, wavy hair is divided by a simple central part and dressed in two softly waving bands, filling out over the temples and bound together at the nape. This type of hairstyle, enhanced with curls over the temples, remained in fashion through the mid-first century A.D., albeit with some variations, and is amply attested in the Vesuvian region. During the reign of Nero (A.D. 54–68), the central part fell out of favor, and women chose to wear close and ever more elaborate curls across brow and along the temples, with the rest of the hair gathered in plaits bound at the nape and falling over the shoulders. During the reigns of Vespasian (A.D. 69–79) and Titus (A.D. 79–81), the crown of curls about the head grew taller and fuller, to the extent that women seeking to follow the dictates of fashion resorted to adding false curls to make the hair more voluminous.

Such elaborate hairstyles obviously called for the right tools. A slave who was expert in hairdressing (*ornatrix*) would bend over backward to satisfy a mistress's whims—without always

Portrait of Livia (in Daremberg and Saglio I.2, fig. 1855). **Portrait of Octavia** (in Daremberg and Saglio I.2, fig. 1856).

succeeding. Such failure could arouse the good lady's ire and try her patience; indeed, she would not think twice about punishing her slave: "Don't be tiresome, don't have your hairstyle done and undone, and leave your hairdressers in peace; I can't bear those women who scratch their hairdressers' face, seize the hairpin from their hand, and jab it into the arm" (Ovid, *Art of Love* III.236–240).

Occasionally, when she wanted some particularly elaborate hairstyle, a Roman lady would go to the hairdresser's shop (*tonsor*)—a type of establishment known to exist in Pompeii (*Corpus Inscriptionum Latinarum* IV.743).

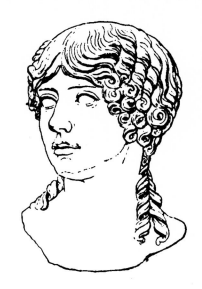

Hairdressing tools were fairly simple. To start with, of course, there was the comb. It was usually made of wood (perishable as it was, no wooden examples have survived), bone, or ivory, but it might also be made of metal. Combs generally consisted of two opposite rows of teeth, one broad, the other close and narrow. We need not dwell on its function, which has not changed since. As Martial ironically points out, a comb was of little use to those who had lost their hair: "What will the boxwood comb you've been given have to do? Bristling with teeth, as it won't find a single hair here?" (*Epigrams* XIV, *Apophoreta*, 25).

Another hairdressing tool, the *calamister* or *calamistrum*, was used to curl the hair in the desired direction. It consisted of a hollow metal cylinder with a solid cylinder inside: the hair would be wound around the solid cylinder and inserted into the hollow one, which had been heated on the fire, much like modern hair-curling irons.

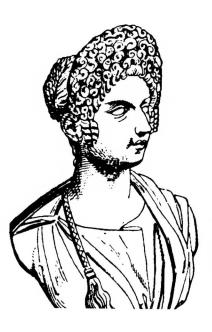

Portrait from the Julian-Claudian Age (in Daremberg and Saglio I.2, fig. 1857).

Portrait of Julia, daughter of Titus (in Daremberg and Saglio I.2, fig. 1859).

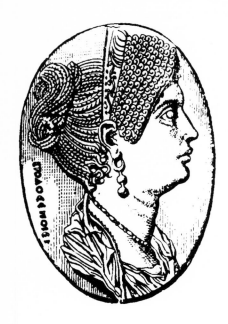

Stickpins, which were usually made of bone, had a very important place in the toilet bag. Classical authors describe various uses for these small sticks that were tapered at one end. We have already mentioned one possible use, as eyeliner applicators (see p. 12), and they might have been to apply other types of makeup as well.

In hairdressing, stickpins were used to separate the locks of hair in much the same way the end of a comb is used today, in which case it took on the specific name of *acus discriminalis*. However, the stickpin was most often used as a hairpin (*acus crinalis* or *acus comatoria*); it held the hair in place once hairdressing was completed: "Lest your hair sopping with ointment should stain your splendid silk dresses, spear it on a pin to support the braided locks" (Martial, *Epigrams* XIV, *Apophoreta*, 24). Some stickpins are very simple, with a little sphere or head of simple geometrical form at the end opposite the point; others are more elaborate, with a head in the shape of a hand or female bust or statuette. As for the material, they were usually made of bone or ivory with silver, but might also be glass or gold. The fact that they rarely appear in iconographic sources may indicate that they performed their function unseen—that ancient wearers hid them in the hair. This is certainly a reasonable explanation for the simpler specimens, but would hardly apply to the pins with figured or bejewelled heads. Scissors, too, found a place in the toilet case, being used to cut hair and trim eyebrows.

Various and elaborate as they certainly were, hairstyles alone

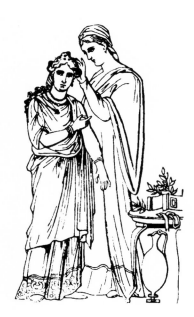

Portrait of Julia, daughter of Titus (in Daremberg and Saglio I.2, fig. 1860).

Drawing after a painting from Herculaneum of an *ornatrix* (in Daremberg and Saglio IV.1, fig. 5429).

were not enough to satisfy female taste. For example, women who were not content with the natural color of their tresses would dye their hair. Hair dyes were usually vegetable based. The ground leaves of henna, a plant imported from the East and Egypt, was used to dye hair red. *Sapo*, a mixture of animal fat and ash, preferably from beechwood, gave the hair a blond or reddish hue, in imitation of the northern peoples whose hair apparently had particular appeal for both Roman men and Roman women. Moreover, in those very same regions, both men and women would dye their hair with tints in a variety of colors. To our knowledge, for example, there was the *pila mattiaca*, named after the city of Mattium near modern-day Wiesbaden in Germany, and *spuma batava* from Batavia, corresponding to what is now Holland. Men and women evidently resorted to these tints when their hair began to turn white, as attested by the many critical and ironical references in writings of the time: "Women disguise their greying hair with Germanic herbs and apply their arts to finding a color more becoming than the natural one" (Ovid, *Art of Love* III.163–164). And again: "If you want to change your old hair turned white, . . . get the dye of Mattium" (Martial, *Epigrams* XIV.27). Tints are also used to change color—not only to blond or red but also to blue and purple: twentieth-century punks are not so original after all! Naturally, these fashions also drew the fire of the poets, satirical and otherwise: "Now, you crazy girl, will you play at aping the painted Britons, tinting your hair with a foreign color? All looks are beautiful as nature has made them . . . even in the Underworld many ills befell that girl

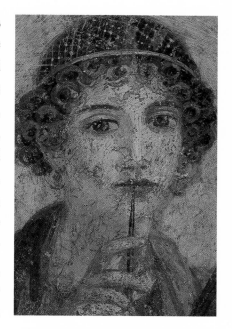

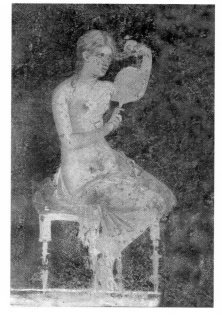

Painting of the so-called Sappho. Pompeii. Museo Archeologico Nazionale, Naples, inv. 9084.

Painting of girl combing her hair. From Villa di Arianna, Stabiae. Museo Archeologico Nazionale, Naples, inv. 9088.

who foolishly changed her hair, lying" (Propertius, *Elegies* II.18b).

A faster and more radical solution was to resort to wigs and false locks of hair, both to keep up with the increasingly complicated hairstyles in vogue and, especially from the Flavian period on, to hide hair that had turned white or was no longer found pleasing and to cover up baldness. Frequent use of tints and the considerable heat applied to curl the hair with the *calamistrum* took their toll, and fair locks were eventually lost: "I told you so: stop dying your hair.' Now you have no more hair to dye. . . . All that patience, offering them up to iron and fire . . . the fair locks fell. . . . Now Germany will send you the hair of slaves" (Ovid, *Gli Amori* I.14). Of course, wearing false hair was nothing to boast about: "Fabulla swears that the hair she has bought is hers" (Martial, *Epigrams* VI.12), but the use was universally acknowledged: "You use purchased hair and teeth and you're not ashamed to. How will you manage with your eye, Lelia? You can't buy eyes" (Martial, *Epigrams* XII.23). So it was not only the hair that might be false, but also the teeth, and even the eyebrows: "Trifena's maidservant leads Giton below and sets one of the lady's wigs on his head. Then she produces eyebrows from a pyx and skillfully arranges them along the traces of the real ones, restoring to him all his beauty" (Petronius, *Satyricon* CX). These were operations to attend to in the privacy of one's own rooms, taking time and care over them, as Ovid warns: "A woman who has ugly hair should keep a guardian at the door. . . . One day I was unexpectedly announced to a young girl, and in the confusion she put her wig on back-to-front" (Ovid, *Art of Love* III.243–246).

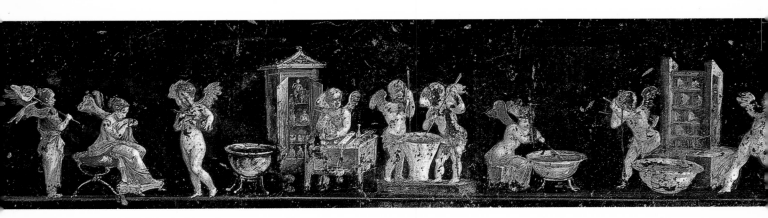

Fresco of cupids as perfume-makers. From Casa dei Vettii, Pompeii.

Naturally such products were too delicate to survive the millennia and no trace of them remained in Pompeii, but we may reasonably assume that they were used by well-to-do women in the Vesuvian city just as in Rome.

While we are on the subject of hair and hairdressing, we may also mention hairnets and hair-bags. The former (*reticula* or *retiola aurea*) were in fact nets of fine gold wire, possibly adorned with jewels, having an essentially decorative function. To judge by the archaeological evidence, they must have been quite rare, possessed only by woman of the upper class or those who enjoyed considerable wealth, like the bride of Trimalchio in the *Satyricon*: "In the end, it came to the point that Fortunata . . . removed [from her head] the gold hairnet, which she averred was of the purest metal" (Petronius, *Satyricon* LXVII).

The latter category includes the *resica*, a bag made from the bladder of a small animal that was not so much an ornament as a form of protection against dust and moisture. A *resica* was used to keep the hair dry in the baths, much like a modern bathing cap is. Unlike hairnets, some fragments of which have been conserved, no hair-bags have survived. Mirrors, by contrast, are well represented. Then as now, they were fundamental tools of grooming, used to verify the lengthy phases of beauty treatment step by step—and to confirm whether the final result met expectations: "There is not just one type of adornment; let every woman choose that which best becomes her, after due consultation of her mirror" (Ovid, *Art of Love* III.135–136).

While round mirrors and other types already known in the Greek and Etruscan world continued to be used, there was a notable predilection among Romans for square and rectangular mirrors, with or without handles. Most of the ancient Roman mirrors were made of bronze, with silver ones a rarity. The metal itself was polished to a high reflective surface. It was only later, in the third century A.D., that a thin layer of blown glass would be applied to the metal. The quadrangular mirrors were very simple, but the round ones often displayed bas-relief or openwork decorations on the rims. The back of the mirror might also show decoration, from simple concentric circles to medallions with separately crafted work in high relief. Among the superb examples uncovered in the neighborhood of Vesuvius we may mention the Boscoreale mirror and the one found in the

DON'T BE TIRESOME, DON'T HAVE YOUR HAIRSTYLE DONE AND UNDONE, AND LEAVE YOUR HAIRDRESSERS IN PEACE; I CAN'T BEAR THOSE WOMEN WHO SCRATCH THEIR HARIDRESSERS' FACE, SEIZE THE HAIRPIN FROM THEIR HAND, AND JAB IT INTO THE ARM.
OVID, *ART OF LOVE* III.236–240

House of Menander at Pompeii. If the mirror had a handle it might be fashioned in one of various forms. The most typical handle was shaped like a club with a *leonté* (lion's skin) wrapped around it, thus also forming the joint between handle and mirror.

A Few Drops of Seduction

The finishing touch to these toilet preparations was provided by perfume, a term that originally referred to the aroma produced by burning fragrant substances (*per fumum*). The origin and use of fragrant essences date back to earliest antiquity. According to Pliny (*Natural History* XIII.2-3), perfumes were invented by the Persians, who dabbed themselves so liberally that their bodies were literally dripping with the essences. Actually, the practice goes back far earlier: perfumes were used in the Egypt of the Pharaohs, for example. In any case, the countries of the East and Egypt were great producers, although perfume factories were also found in Campania itself in the Roman period, when Capua and Naples were the major production centers. On the evidence of ancient inscriptions, Pompeii also had its perfumeries. Moreover, two inscriptions attest to the presence of a corporation of perfumers whose headquarters seems to have been situated near the *macellum*, Pompeii's major market, and thus in the heart of the city. Palaeobotanical investigation in the *Casa del giardino di Ercole* (or *Casa del Profumiere*) has revealed intensive cultivation of olives and flowers—perfume's basic ingredients—in the large garden, so it seems quite likely that there was a production center here, too. Indeed, the whole area around Pompeii shows an abundance of plant essences suitable for the production of perfumes, which suggests that there may well have been a local market associated with perfume-making in the area. Various paintings at Pompeii and Herculaneum show cupids intent on the work of perfume production: pressing the plant substances, macerating them in a cauldron, and storing the bottled perfumes in a cabinet. One series concludes with the customer appraising the fragrance with a sniff on the wrist, thus performing a gesture that has not changed over the millennia. The choice of such scenes to decorate the houses of the well-to-do (perfume production involved a considerable investment) has been interpreted as pointing to a connection between the householders and the perfume industry.

YOU USE PURCHASED HAIR AND TEETH AND YOU'RE NOT ASHAMED TO.
HOW WILL YOU MANAGE WITH YOUR EYE, LELIA? YOU CAN'T BUY EYES.
MARTIAL, *EPIGRAMS* XII.23

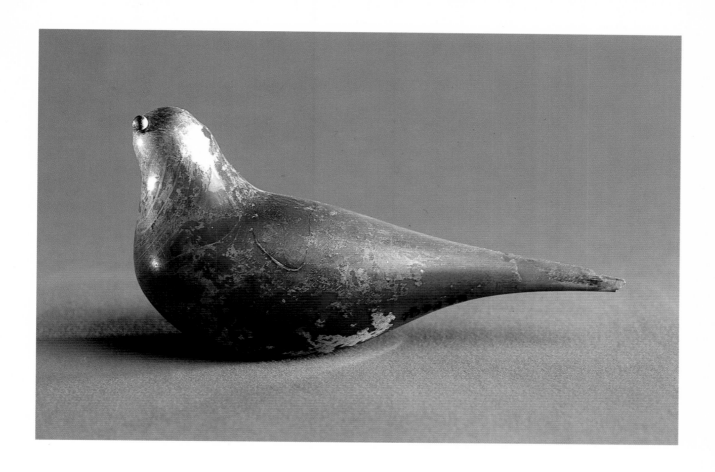

There were two basic categories of perfumes. The first consisted of *diapasmata*, which were dry preparations made by pulverizing aromatic plant substances. These were sold in the form of powders or tablets and were used to fight excessive sweating, armpit odors, or bad breath—albeit not always successfully, as Martial pointed out: "To avoid stinking too much of the wine you drank yesterday, Fescennia, gorge yourself on the tablets from Cosmo's perfumery. These preparations plaster the teeth, but they are no use when a belch rises from the depths" (*Epigrams* I.87). The second category, obtained by mixing a volatile substance (*sucus*) and a vehicle (*corpus*) to ensure lasting duration, consisted—as the name *unguentum* itself suggests—of animal

Dove-shaped unguentarium. (Museo Archeologico Nazionale, Naples, inv. 109433).

or, more often, vegetable fats (oil obtained from olives, walnuts, or almonds) or resins. *Omphacium*, the juice of unripe grapes, might also be used, which seems particularly appropriate as it is colorless, odorless, and, moreover, not greasy. The essences were extracted with a press or with mortar and pestle. Otherwise, the essences could be left to macerate in the fat vehicle.

On the evidence offered by the authors of the time, the Romans made lavish use of these products, and indeed the richer households had a *cella unguentaria* and a slave to safeguard the crates of perfumes—or at least such was the case in Trimalchio's household (Petronius, *Satyricon* 74). Things were probably not quite like this in Pompeii, which remained a provincial city despite its thriving economy.

Perfumes were lavished not only on the body (after the bath and during banquets) but even on the house itself. For example, perfumed oils were added to lanterns, as Martial tells us (*Epigrams* X.38). They were used by men and women alike, giving the satirical poets of the time, like Martial, ample subjects for ridicule: "Sure as you are sure of your cinnamon and spices, and essences extracted from the Phoenix's nest, reeking of the perfumes that Niceros keeps in lead pots, Coracinus, you laugh at me and my lack of perfume: I prefer to have no odor rather than reek to high heaven!" (*Epigrams* VI.55). Again: "When you pass by it's as if Cosmo the perfumer were moving shop, and cinnamon streamed from an upturned bottle. I don't want you, Gellia, to take to such futile things. You know, I think even my dog could smell as well perfumed" (*Epigrams* III.55). And in his tirades against luxury, Pliny remarked that, of all forms of wastefulness, perfumes, which were in general quite costly, were the most absurd and ephemeral: at least jewelry can be passed on to heirs, but perfumes instantly evanesce! (*Natural History*, XIII.20). However, we can find appreciative observations, too, as in the delightful poem in which Catullus invites his friend Fabullus to dinner: "But I shall return your favor with sweetest of refinements: in fact, I shall give you a perfume conferred on my sweetheart by Love and Desire, and when you smell it, o my Fabullus, you will pray the gods to make you all nose!" (Catullus, *Poems* 13.10-14).

Once produced, the perfumes were bottled for sale in characteristic containers (*unguentaria*)

BUT I SHALL RETURN YOUR FAVOR WITH SWEETEST OF REFINEMENTS: IN FACT, I SHALL GIVE YOU A PERFUME CONFERRED ON MY SWEETHEART BY LOVE AND DESIRE, AND WHEN YOU SMELL IT, O MY FABULLUS, YOU WILL PRAY THE GODS TO MAKE YOU ALL NOSE!
CATULLUS, *POEMS* 13.10-14.

made mostly of glass in various shapes and sizes. Perfume bottles tended to be small, blown-glass objects fashioned in the shape of miniature amphorae or bottles with long, narrow necks. Relatively few examples survive of the small, bird-shaped *ampullae*. These were sealed with glass once they were filled; to use the contents, you had first to break off the tip of the bird's wing or beak.

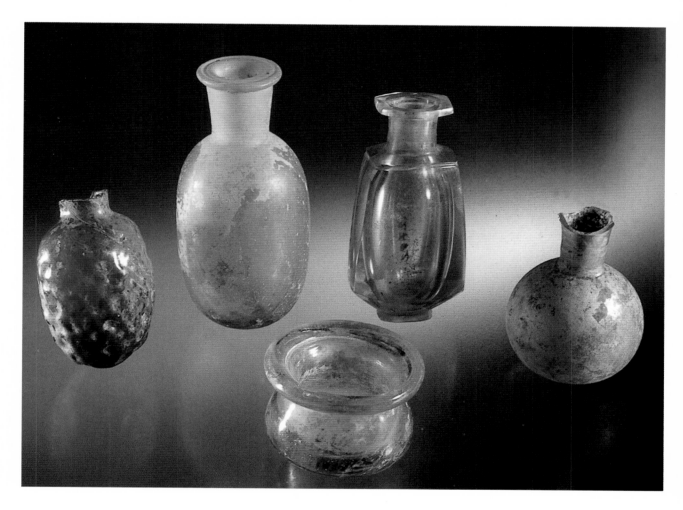

Unguentaria made of glass. Pompeii.

WHEN YOU PASS BY IT'S AS IF COSMO THE PERFUMER WERE MOVING SHOP, AND CINNAMON STREAMED FROM AN UPTURNED BOTTLE. I DON'T WANT YOU, GELLIA, TO TAKE TO SUCH FUTILE THINGS. YOU KNOW, I THINK EVEN MY DOG COULD SMELL AS WELL PERFUMED.
MARTIAL, *EPIGRAMS* VI.55 AND III.55.

Catalogue of Items Commonly Used for Body Care

1. Smoother

Inv. 6842. Pumice stone and bronze. Pompeii, I.8. Diam: 5.7 cm.

The pumice stone was rubbed over the skin to make it smooth. To ensure a good grip, the stone was inserted in a bronze lamina pouch.

In use in the first century A.D.

2. Auriscalpium

Inv. 10716 D. Bone. Pompeii, II.1.4. Length: 9.2 cm.

Small sticks of this type, ending in a slightly tilted disk, were used to clean the ears (*auriscalpia*) or to mix and spread cosmetic creams. They were probably also used to extract the creams from their containers.

In use in the first century A.D.

3. Tweezers

Inv. 12452 A. Bronze. Pompeii, from house I.18.5. Length: 8 cm.

4. Tweezers

Inv. 3139 A. Bronze. Pompeii, from house VI.16.11. Length: 8.1 cm.

The looped end (possibly to go on a ring together with other toilet items) and diminutive proportions suggest that these tweezers served cosmetic purposes such as hair removal.

In use in the first century A.D.

5. Spatula

Inv. 9810. Bone. Pompeii, from house I.9.10. Length: 15.8 cm; width: 1.6 cm.

Spatula with the broad end spoon-shaped and the other end flat; decorated with incisions giving it a fingerlike appearance. Probably used, somewhat like a strigil, to remove the excess of creams that women would spread liberally over their bodies after a bath.

In use in the first century A.D.

6. Spatula

Inv. 10672 A. Bone. Pompeii, II.1.4. Length: 14 cm; width: 2 cm.

Spatula decorated with grooves, imitating a fingertip at one end. It was probably used to extract, amalgamate, and apply cosmetics.

In use in the first century A.D.

7. Spoon

Inv. 13037 B. Bone. Pompeii. Length: 10.7 cm; width: 1.3 cm.

Spoon-shaped spatula, probably used to extract cosmetic creams and powders from containers.

In use in the first century A.D.

8. Spoon

Inv. 14259. Bone, Pompeii, western insula, House of the Gold Bracelet. Length 8.7 diam. 2.

This type of spoon was used both to extract cosmetic creams and powders from containers and to eat eggs and shellfish. Spoons used for the latter purpose were usually made of metal.

In use in the first century A.D.

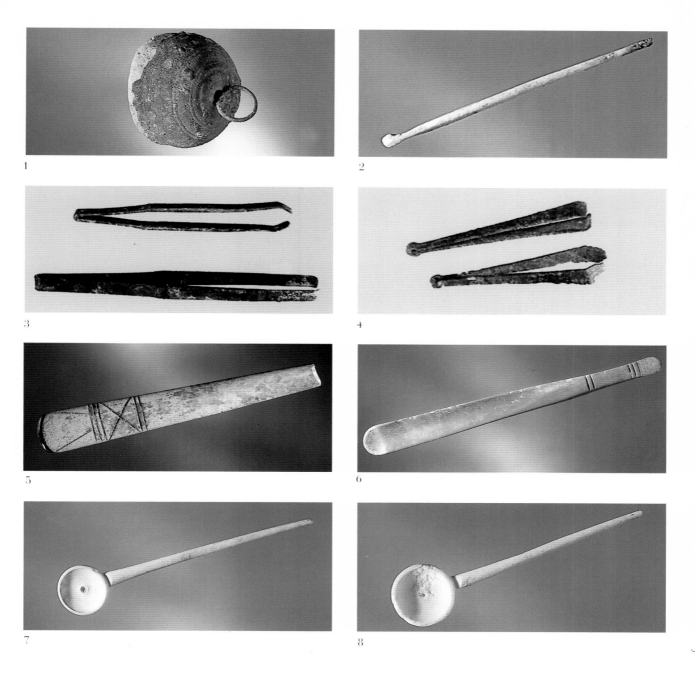

1

2

3

4

5

6

7

8

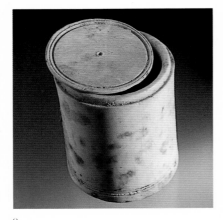

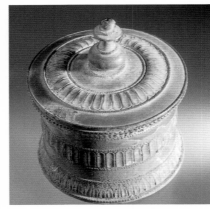

9 10

9. Pyx

Inv. 10390. Bone. Pompeii. from house II.1.2. Height: 4.2 cm; diam: 3.3 cm.

Small cylindrical container used for holding cosmetic products. The bottom, base, and lid are decorated with concentric grooves.

In use in the first century A.D.

10. Pyx

Inv. 10025. Bronze. Pompeii, I.9.11. Height: 9 cm; diam: 7.9 cm.

Finely chased cylindrical container, probably for holding small toilet items.

In use in the first century A.D.

11. Portrait of a lady

Inv. 124666. Mosaic. Pompeii, from house VI.15.4; now in the Museo Archeologico Nazionale, Naples. Height: 25.5 cm; width: 20.5 cm.

The hair is combed with a central part and bound with a ribbon at the back of the neck. The type of mosaic, with its tiny tesserae, and the woman's earrings, which are of Hel-

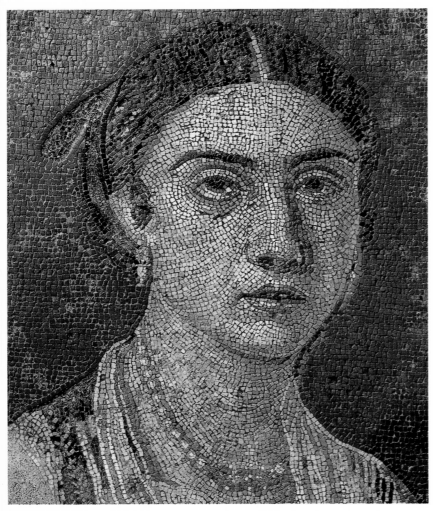

lenistic tradition, suggest a date in the first century B.C., before 30–20 B.C.

12. Portrait of a lady

Inv. 4990. Bronze. Pompeii, from the House of the Cithara Player (I.4.5); Museo Archeologico Nazionale, Naples. Height: 37 cm.

The hairstyle, with a central part and long locks forming a mass of curls on the temples and at the sides of the face, was fairly common in the early first century A.D.

13. Combs

Inv. 11883 A. Bone. Pompeii, from house I.18.3. Length: 5.4 cm; width: 3.8 cm. Comb with two rows of teeth, one with tines set slightly closer. Less common than the type with one

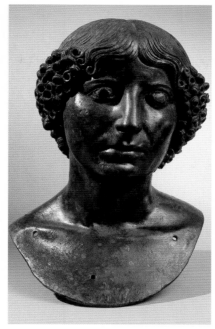

12

row, which was usually made of wood.

In use in the first century A.D.

14. Hairpin

Inv. 1992. Bone. Pompeii, from house I.12.5. Length: 10 cm.

Hairpin with hand-shaped handle holding a globular object, possibly a pomegranate, with three spread fingers. The fruit symbolized rebirth after death.

In use in the first century A.D.

15. Hairpin

Inv. 13288. Ivory. Pompeii, from house I.12.6. Length: 10.5 cm.

Hairpin with hand-shaped handle; in relief, a bracelet in the form of a serpent circles the "wrist." The type is known in Italy, Greece, and Gaul in the first century A.D., particularly in the latter half.

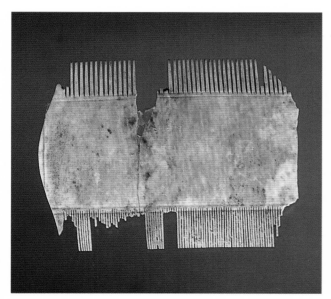

13

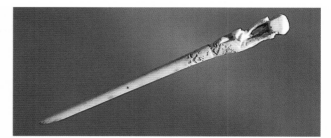

14 - 15

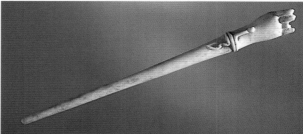

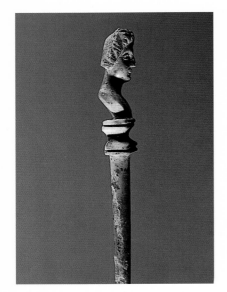

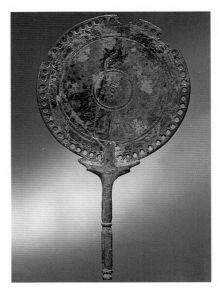

17. Hairpin

Inv. 11647. Bone. Pompeii, from house I.13.3. Length: 12.7 cm.

Hairpin. The handle depicts the goddess Venus wringing out her hair after bathing. Hairpins with a handle in the form of a female figure, usually Venus, were common in the first century A.D., especially in the first half of the century, and have precedents in the Hellenistic age.

18. Hairpin

Inv. 12244. Bone. Pompeii, from house I.14.13. Length: 11 cm.

Hairpin with handle in the form of a female bust on modelled base. This type began to circulate around the mid-first century A.D., gradually replacing the type with the standing female figure.

18

16. Hairpin

Inv. 13290 A. Bone. Pompeii, from house I.12.6. Length: 7.6 cm.

Hairpin with modelled handle ending in the shape of a pinecone, a motif symbolizing immortality. This type was particularly common in the latter half of the first century A.D.

19

19. Mirror

Inv. 10790. Cast bronze. Pompeii, from house I.11.6. Length: 14.2 cm; diam: 8 cm.

Mirror edged with openwork decoration and modelled handle. The disk is silver-plated, both on the smooth reflecting side and on the reverse, which

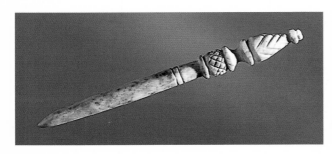

16

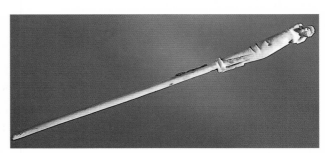

17

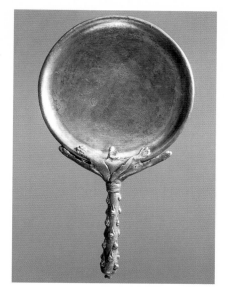

20

is decorated with concentric grooves.

20. Mirror

Inv. 30796. Cast silver. Terzigno, villa 2.
Length: 20 cm; diam: 12 cm.

Mirror with handle modelled in the
shape of a club ending with a *leonté*
(lion's skin) forming the joint with the
disk. Club and lion's skin are attrib-
utes of Hercules, and the mirror as a
toilet item for women recalls the myth
of Omphale, the mythical queen of
Lydia, who seduced the hero.

This type of mirror was common
in the first century A.D.

21-23. Unguentaria

Inv. 14225. Blown glass. Pompeii, western
insula. House of Fabius Rufus. Height: 7.7
cm; diam: 2.9 cm.

Inv. 5839 A. Blown glass. Pompeii, outside
the walls. Height: 11.8 cm; diam: 1.7 cm.

Inv. 11567 A. Blown glass. Pompeii, from
house I.13.3. Height: 4 cm; diam: 3.1 cm.

Small bottles used for perfumes or
ointments. The stoppers for these
types of containers (*unguentaria*)
have never been found; they
must have been made of a perish-
able material such as cork. *Un-
guentaria* were common in the first
century A.D.

24. Unguentarium

Inv. 11568 A. Glass blown in a mold.
Pompeii, from house I.13.3. Height:
4.2 cm; diam: 2.6 cm.

This belongs to the category of
unguentaria with a body in the
shape of an acorn, pinecone, or
bunch of grapes, common in the
first century A.D. They may have
been fashioned to hold a particular
type of perfume associated with the
shape of the bottle.

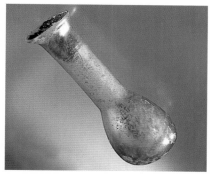

21

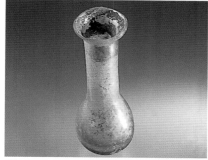

22

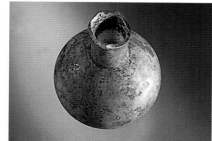

23

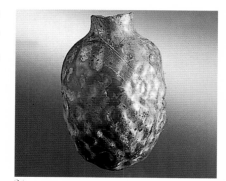

24

JEWELRY

Prevalence and Fashions

Thus washed, depilated, rejuvenated with beauty masks, groomed, and perfumed, our lady is ready to deck herself out with her jewelry.

It was only in the first century that luxury, and with it jewelry, became common in everyday life. This occurred after the Romans had one by one subdued Carthage, Macedonia, Greece, Syria, and the various realms of Asia Minor, culminating with the triumph over Mithridates, king of Pontum, by Sulla and subsequently, in 61 B.C., by Pompey. Apart from a general increase in affluence, an important factor in this growing prevalence was the sheer quantity of precious materials and objects flowing into Rome from various places as spoils of war. As the first century A.D. rolled by, the sober, austere matrons of antiquity described by time-honored tradition were transformed into frivolous fillies dripping with jewels, at least in the eyes of "right-minded" Romans and according to the satirical poets, who expressed their disapproval through biting irony. It was not just a matter of custom; Roman writers were also concerned that over-indulgence in jewelry fashioned from precious materials that had been acquired outside Italy might dissipate the wealth Rome had so laboriously accumulated: "What am I to castigate first . . . that folly peculiar to women, thanks to which our wealth is passed on to foreign or hostile peoples?" (Tacitus, *Annals* III.53). Again: "India and the Sers and that peninsula (Arabia) tear hundreds of thousands of sesterces from our empire, at a modest estimate. So much do luxury and women cost us." (Pliny, *Natural History* XII.84). It was above all the fashion for precious

Detail of a sphere-segment earring showing a surface covered with tiny embossed dots (see p. 52, fig. 7). Villa of Crassius Tertius, Oplontis

stones that came into vogue, reaching a mania well documented in Pliny's descriptions of Lollia Paulina, Caligula's wife, setting off to a minor ceremony "covered in emeralds and pearls . . . with glittering jewels on her head, in her hair, on her neck, ears, and fingers" (*Natural History* IX.117 ff.). Sometimes, however, it was concern over something rather closer to home than the state coffers that fired disapproval: "It came to the point that Fortunata [Trimalchio's wife] took her bracelets off her monstrously fat arms to display them to the wonder of Scintilla. Finally, she also took the rings from her ankles and the gold hairnet from her head. . . . 'See,' said Trimalchio, 'what blessed fetters women wear! And we fools let ourselves in for this plundering. It must weigh six and a half pounds.' . . . Scintilla was not going to be left behind, she took a gold case from her neck . . . and took out two *crotalia* [pearl earrings] for Fortunata to admire. . . . 'What?' said Abinna [Scintilla's husband], 'you bled me dry to buy you those glass beans. I can tell you, if I had a daughter I'd cut her ears off!'" (Petronius, *Satyricon* LXVII).

Of course, these were extreme cases, such as could occur only among the wealthiest classes. Things were quite different in the towns around Vesuvius, which may have been prosperous but remained essentially provincial. Indeed, the evidence those towns offer—which is the most copious to survive and occurs in the fullest context—consists with few exceptions of a modest array of trinkets much like those found in other parts of Italy. The truly exceptional pieces that were evidently possessed only by the grandes dames of the aristocracy and the imperial house were lacking. In keeping with what we take to have been the current fashion, evidently reflecting the taste and pockets of the middle classes of the time, jewels from the Vesuvian area display relatively simple crafting, with surfaces often left plain or at best decorated with simple embossed motifs. Moreover, filigree motifs and, in particular, the granulation that played such a part in the exuberant but refined elegance of jewelry produced by the Etruscans and in *Magna Graecia*, are virtually absent (surely reflecting taste rather than technical incapacity). On the other hand, gems enjoyed great favor, as we have seen, thanks in part to the chromatic contrasts they produced with gold as well as the amuletic powers attributed to many of them.

It is also significant that evidence from the Vesuvius area reveals a difference only in quantity—not in quality—between the jewelry from dwellings of families displaying average affluence and jewelry from the houses of the top ruling class in the area.

. . . COVERED IN EMERALDS AND PEARLS . . . WITH GLITTERING
JEWELS ON HER HEAD, IN HER HAIR, ON HER NECK,
EARS, AND FINGERS
PLINY, *NATURAL HISTORY* IX.117 FF.

Materials and Techniques

What materials were used in the manufacture of jewels, and what techniques were employed? Of jewelry conserved in the Vesuvius area, those made of gold, or of gold with gems, are by far the most frequently found. There are few examples of silver jewelry, and even fewer pieces in bronze or iron—and practically all of those are rings. However, this finding may have been affected by the properties of the metals themselves: gold is able to withstand the elements, while the other metals are subject to oxidation and thus are perishable. We shall therefore confine our attention to examples in noble metal.

Gold-crafting techniques remained virtually unchanged from the second millennium B.C. to the late Roman period and beyond, the tools being extremely simple: a crucible, an anvil, hammers and pincers of various sizes, chisels of bronze or iron, molds and stamps, files and abrasives, and drills with various bits for intaglio, or gem-carving.

The basic materials consisted of metal reduced to sheet or wire form; gems; and glass pastes, the latter category being used to make cheaper jewels for the less affluent. This, then, was the kit used to assemble the various parts of a piece of jewelry, which would then be put together—by welding or with some other technique, such as binding with wire—and possibly embellished with additional decoration in the same metal, or with different metals or gems. Hammering red-hot ingots on an anvil produced the sheets, which were then hammered again, this time between two sheets of copper or pieces of leather, to a thickness that might be less than a tenth of a millimeter.

Wire was formed from strips of thin metal sheets that were hammered and rolled between plates

Earrings in gold and beads, detail (see p. 53, fig. 13). House of the Arches, Pompeii.

of bronze or slabs of stone until a circular cross-section was produced. Another method was to twist a strip of metal in a continuous spiral. Thicker wire could be fashioned by casting. As we have seen, wire was used to bind together the various parts of an ornament, create pieces in filigree, or fashion the links of a chain. In fact, the most common type of chain was made by linking together ready-made wire rings.

Most jewels, therefore, consisted of hollow parts of variously modelled and decorated sheets, with wire used mainly to bind the components together. The closed hollow forms made from two parts in sheets were often filled with some other substance (such as resin, sulphur, or wax) to make them more solid and less easily dented. Casting might also produce some types of jewelry (certain rings, for example, or necklace pendants).

The metal sheet that would be modelled to create the body of the jewel was usually smooth, but might be decorated with embossed, moldmade, openwork, or applied motifs. Embossment was usually achieved with a hammer and stamp. The craftsman would beat the stamp on a sheet resting on some yielding material (wood or lead for shallow relief, pitch for a deeper embossing). The finishing touches to the decoration would then be achieved using a chisel.

Motifs were added using the same metal in filigree or applied granulation (which, as we have seen, was rare in Roman jewelry): threads or grains of gold, respectively, would be welded to the surface of the smooth sheet to form a design. An example of a motif in a different material being added can be seen in the gold eyes on serpent-shaped silver bracelets.

Intaglio was achieved using drill bits of various shapes and thicknesses, reinforced with splinters of semiprecious stones or diamond dust. During this minute crafting, bowls of water may have been used for magnification, although lenses were already known at the time.

All these operations were performed by a great variety of craftsmen, usually *liberti* (freed slaves), but both slaves and free men carried out apparently highly specialized craft activities. Thus, in addition to the *aurifex* (a term designating both goldsmiths and sellers of gold), there were the *brattiarius*, who specialized in beating gold into the thinnest of sheets; the *barbaricarius*, an expert in gold embroidery; and the *caelator*, who did the chisel work. The *anularius* and *armillarius* specialized, respectively, in manufactur-

. . . YOU BLED ME DRY TO BUY YOU
THOSE GLASS BEANS
PETRONIUS, *SATYRICON* **LXVII.**

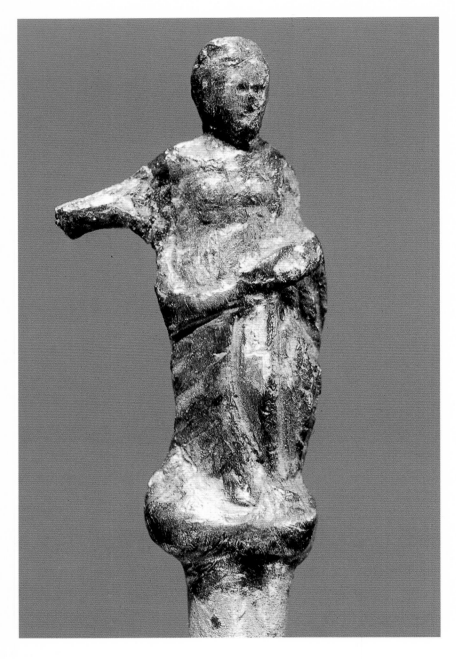

Silver hairpin, detail (see p. 51, fig. 4). Oplontis.

ing rings and bracelets; the *scalptor* specialized in intaglio; and the *gemmarius* could be either the person who sold gems or the one who cut them.

At Pompeii we know of two houses-cum-workshops belonging to *gemmarii*, but we have no clear evidence of goldsmiths' workshops, although their presence is indicated by an electoral inscription, *All aurifices universi ask* (*Corpus Inscriptionum Latinarum* IV.710). Among the famous wall paintings in the House of the Vetti is a scene showing cupids intent on various phases of the goldsmith's art.

It is hoped that this long technical digression will help readers form a clearer picture of the jewelry we shall be considering.

The Sites of the Finds

We have already discussed the truly extraordinary archaeological evidence offered by the towns in the

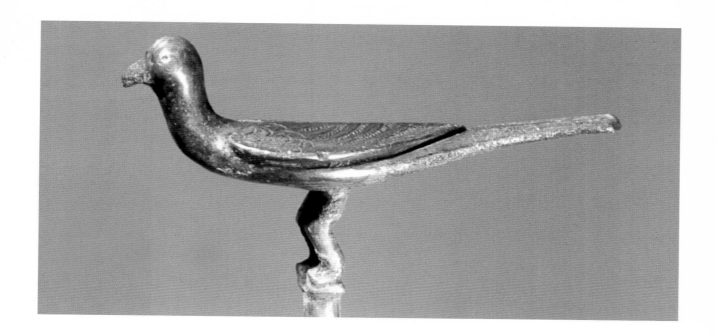

neighborhood of Vesuvius, which were buried so suddenly and rapidly that objects of everyday life have been conserved virtually intact in their original contexts. Thus, archaeologists have been able to reconstruct and appreciate an object's relationship with a dwelling and even, in some cases, with individual people. Clearly, however, an opportunity like that does not always arise, and in the past (before the more painstaking modern methods of excavation were systematically applied) such opportunities were often not fully exploited.

For example, during early excavations jewelry was found in a great many houses at Pompeii, but all too often no precise records were made in the excavation report of the context and condition of a find. Thus we have a fragmentary array of data rarely affording the possibility of accurate reconstruction and with it analysis of the contexts.

Among the significant exceptions are the objects found in the House of Julius Polybius and in the houses-cum-workshops of Pinarius Cerialis and "the Gemmarius." Excavation revealed a number of small safes stashed with jewelry as well as various objects interpreted to be tools for gem-crafting. Such finds are important not

Silver hairpin, detail (see pp. 50–51, fig. 3). Pompeii.

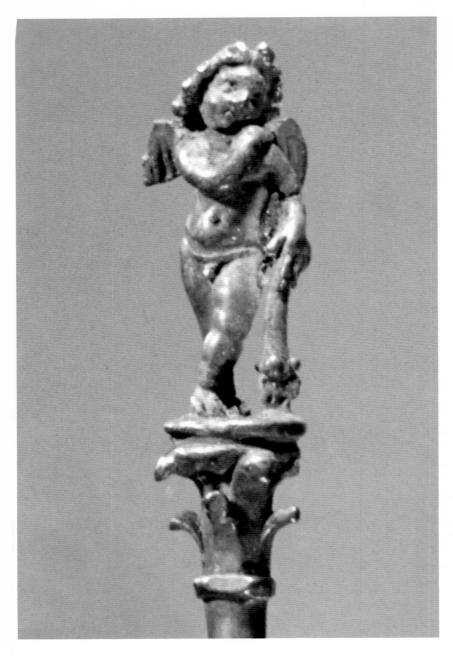

Silver hairpin, detail (see p. 50, fig. 2). Pompeii.

only for the sheer beauty of the jewelry itself but also because they confirm the presence of goldsmiths in Pompeii.

The House of Julius Polybius offers precise evidence of the jewelry worn (and probably also all the jewelry owned, as no other jewelry was found in the house) by an individual woman belonging to the ruling class of Pompeii. The people living in the house, Julius Polybius and Julius Philippus, both played successful roles in the political life of Pompeii.

A similar state of affairs was found with excavation of a villa in the area of the present-day village of Terzigno, on the slopes of Vesuvius. The remains of a woman, a victim of Vesuvius, were found here, with a variety of jewelry, coins, and silver vessels next to her. Evidently she had been trying to rescue those valuables as she fled.

Excavations at Oplontis and

Herculaneum revealed even more dramatic circumstances and a wealth of precious finds. At Oplontis, a small center not far from Pompeii corresponding to modern-day Torre Annunziata, at least fifty skeletons were found jostled together in a room, some piled on others, some wearing jewelry, others with the jewelry and money they had been trying to save beside them.

Much the same situation was discovered at Herculaneum with the excavation of rooms overlooking the ancient marina, where many victims had sought refuge while waiting for the right time to make their escape by sea.

Altogether we have a range of situations, from finds clearly attributable to particular individuals to those that can be associated with dwellings; even the odd finds of objects in the street, which were probably dropped by panic-stricken Pompeians as they fled. The overall picture is rich and varied, and the problem facing researchers is to understand each situation and find the right clues to piece the parts together.

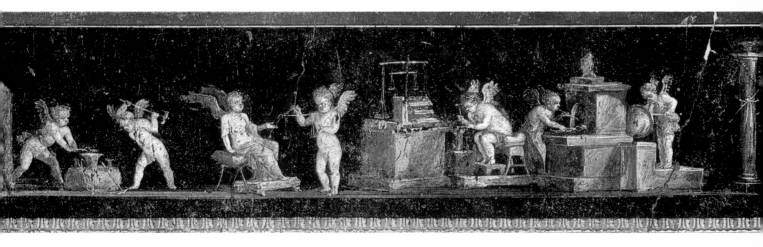

Fresco of cupids as goldsmiths. Casa dei Vettii. Pompeii.

Types of Jewelry

We have already discussed the use of gold hairnets (see p. 19). To these adornments, Roman women added ribbons and bands (*vittae*), often made of costly materials, which completed and enhanced the headdress. Unfortunately, they were perishable, and no examples have survived.

Some rare examples do exist of diadems in plain gold, with decoration embossed or in openwork, and in gold and jewels. There is a a truly splendid gold specimen from Pompeii with large, highly ornate pearls.

On the other hand, we have ample evidence of hairpins (see discussion on pp. 15–16), undoubtedly one of the most characteristic objects for adorning the head. Apart from examples in such common materials as bone, iron, and bronze, the Vesuvius area also yielded twenty-three silver haipins and four gold ones, the latter typically displaying a head in the form of a vessel decorated with a jewel. The silver hairpins exhibit a wider variety of heads.

Gold diadem with ornate pearls, detail (see p. 50, fig. 1). Pompeii.

Hairpin, detail (see p. 28, fig. 17). Pompeii.

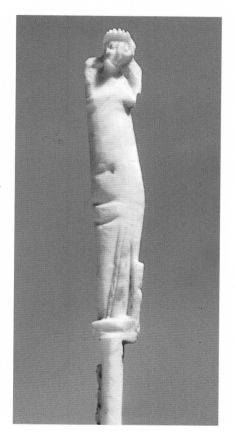

ranging from a simple sphere in
examples shaped like a hand, a

As ample as the evidence may
found in such large numbers as
elry, although they must have been
an mentions "the hairpin deco-
usually have" (*Digest* XXXIV,
greater use was made of the cheap-

"If I had a daughter I'd cut her
passage from the *Satyricon* (Petro-
mous expense of buying his wife
adornments, earrings were partic-
girls of the time. Indeed, on the ev-
women would vie with one anoth-
specimens—to the great discomfort
might vent their feelings in harsh
warn against overindulgence. "Do
jewels [pearls, in this case] which
green waters. . . . Often you put us
of which you seek to attract us"

the shape of a pinecone to
bird, and even a human figure.
be, however, hairpins are not
certain other categories of jew-
widely used in all periods: Ulpi-
rated with a pearl, which women
2.25 and 10). Evidently, much
er type, in bone.

ears off," exclaims Abinna in a
nius, LXVII), chafing at the enor-
earrings. Of all the typical female
ularly sought after by ladies and
idence of the classical authors,
er for the finest and most costly
of their men, who, as we have seen,
criticism, or might more mildly
not burden your ears with costly
the dusky Indian gathers in the
to flight with the luxury by means
(Ovid, *Art of Love* III.129–131).

Such warnings do not seem to have had much effect, however, as Juvenal suggests: "Women think they can
afford to do whatever they like . . . when they hang great pearls on their ears stretched low with excessive
weight" (*Satires* VI.457–459). So earrings—always, or almost always, made of gold, according to the evi-
dence—were the most coveted types of jewelry, especially when richly set with gems. Pearls were particularly
fashionable, and earrings exhibiting one or more pearls were among the most widely used—and the most cost-
ly: "I see they do not stop at attaching one single great pearl to each ear; in fact, by now their ears are accus-
tomed to bearing great weights: pairs combine with or surmount more pairs [of pearls]. Female folly had not

WOMEN THINK THEY CAN AFFORD TO DO WHATEVER
THEY LIKE . . . WHEN THEY HANG GREAT PEARLS ON
THEIR EARS STRETCHED LOW WITH EXCESSIVE WEIGHT.
JUVENAL, *SATIRES* VI.457–459.

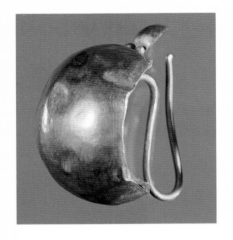

crushed men enough unless two or three entire patrimonies hung from their ears" (Seneca. *On Benefits* VII.9.4).

Let us now take a closer look at the types of earrings most popular among the women of Pompeii and Herculaneum. with gold. of course, always the constituent metal.

First we have the type in the form of a crescent moon, consisting of gold sheet fashioned into a segment of a hollow sphere, either closed on all sides or left open behind. Welded onto the body of the pendant is an S-shaped hook from which the pendant can be hung. Basically, therefore, it is a very simple piece of jewelry, characterized by smooth, convex surfaces that seem to have appealed greatly to the taste of the time, often recurring in other types of jewelry. It has no Hellenistic precedents, but rather seems to have been a creation of the Roman goldsmiths. making its appearance in the first century B.C. and remaining in vogue until the second century A.D. In a more elaborate variant of the model. known in very few examples compared with the basic type. the segment form is decorated with closely embossed dots, in imitation of the more refined and more expensive granulation technique. A very precious and truly rare variant has the earring in the shape of a sector of a sphere that is richly set with gems.

Another simple earring, this one of Hellenistic derivation and in use until the third century A.D.—well after Pompeii had met its catastrophic doom—is the ring type. It consists of a simple ringlet, perhaps decorated with small stones. from which hangs a gold wire adorned with a small pearl or some other gem. As we have seen, earrings with pearl pendants met with special favor. The simplest consisted of an S-shaped hook from which hung a wire of gold bearing a pearl. This model, which ancient sources call the *stalagmium*, has Hellenistic precedents and was in circulation until

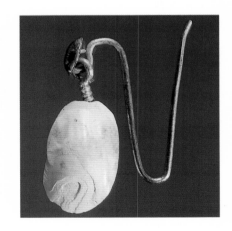

Earrings in smooth gold modeled in the form of a sphere segment (see p. 52. fig. 6). Pompeii.

Earrings in gold and mother-of-pearl (see p. 53. fig. 12). Villa of Crassius Tertius. Oplontis.

Gold choker, detail (see p. 55. fig. 18). Pompeii.

the third century A.D. As Seneca complained, however (see above), it was not enough to attach "one single great pearl to each ear." The first century A.D. saw a new fashion come in that was to last until the third century A.D., this time for earrings with double pendants: the customary S-shaped hook was welded to a small horizontal bar from which hung two gold wires, each bearing a pearl. In ancient times, these earrings were called *crotalia*—an onomatopoeic word imitating the sound of the pearls knocking together as the wearer moved (Pliny, *Natural History* IX.35.56; Petronius, *Satyricon* LXVII). The richer variants of this model, which displayed, as Seneca tells us, pearls in pairs for each ear, do not seem to have been known in the Vesuvian region.

The most flamboyant type of earring is the "basket" or "cluster" type, which was probably more costly and therefore less common, although it was well known in the Vesuvian area. It consists of a hemispheric net in gold wire and sheet gold, into which were inserted small pearls or other gems (emerald beads, for example). A pair from Oplontis exhibit, in the place of the netlike body, a series of bezels welded together and adorned with quartzes.

The necklace was the most important item of jewelry, and one that could come in exceptionally extravagant forms. Although we might expect to find necklaces well represented among female adornments, they are not particularly common in the region around Vesuvius, evidently because they generally cost more than smaller items such as earrings and rings. While only a few necklaces constructed of precious materials have been found, cheaper models in glass paste (not illustrated in this volume) are far more plentiful: no fewer than 170 have been discovered in Pompeii alone.

The most obvious distinction between various types of necklaces is between the *monilia*, which resembles a choker, and the *catenae*. The latter are

I SEE THEY DO NOT STOP AT ATTACHING ONE SINGLE GREAT PEARL TO EACH EAR; IN FACT, BY NOW THEIR EARS ARE ACCUSTOMED TO BEARING GREAT WEIGHTS: PAIRS COMBINE WITH OR SURMOUNT MORE PAIRS [OF PEARLS]. FEMALE FOLLY HAD NOT CRUSHED MEN ENOUGH UNLESS TWO OR THREE ENTIRE PATRIMONIES HUNG FROM THEIR EARS.
SENECA, *ON BENEFITS* VII.9.4.

long necklaces with links made of gold from shoulders to hips while cross- ble adornments include not only bossed decoration, but also the and love. This type of neck- precedents in the Hel- worlds, are seen often in pictions, but very few It is the least common count of its cost, and prerogative solely of *Monilia* were cer- mon, appearing in a els, either in plain gold with gems. Plain neck- tremely simple chain type clasp and a pendant a crescent moon whose tips Variants might show differ- links, clasp, or pendant. Neck- which enhanced the design with were decidedly more elegant—and which are common in other contexts, emer-

wire or sheet gold; they were worn falling ing the chest and the back. Possi- studs, which in turn bore em- wheel as a symbol of fortune lace, for which we can find lenistic and Etruscan painted or sculpted de- have actually survived. type, evidently on ac- seems to have been a the wealthiest ladies. tainly more com- wide range of mod- or richly adorned laces include ex- chokers with a hook- consisting of a *lunula*— meet or almost meet. ences in the design of the laces adorned with gems, highly prized chromatic effects, more costly. In addition to pearls, alds were much sought after "for many

reasons, certainly because no other color has a more pleasing look [than green]. . . . All the more gladly do we look at emeralds because nothing, compared with them, has more intense greens. Moreover, of all the gems only they satisfy the gaze without satiating it" (Pliny, *Natural History* XXXVII.16). More often than not, emer- alds were left virtually uncut—simple smooth prisms often strung like beads, alternating with other gems,

Ribbon-style necklace with emeralds and mother-of-pearl.
Pompeii. Museo Archeologico Nazionale, Naples, inv. 113576.

gold beads, or simple links. The gemological characteristics of the emeralds found in the Vesuvian region indicate they originated from an ancient area of extraction at Mount Zabarah in Egypt.

The "ribbon" necklace, of which very few examples have survived, is a particularly striking type. It consists of various chains with links running side by side so as to form a ribbon into which gems are set.

A much simpler style, and one that saw some popularity, consists of a simple string (*linea*) of pearls, rock crystal, or plain gold. Strands of pearls would have been extremely precious, but none have survived in the Vesuvian area, due to the perishable nature of pearls. Rock crystal came from India, Asia Minor, and the Alps, and was as highly valued as amber and gems. It was often used for the manufacture of vessels or small ornamental ob-

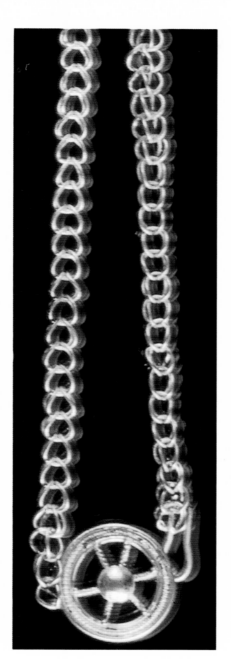

jects, and rather less often for necklaces. Necklace pendants fashioned in crystal are less common around Mount Vesuvius; those conserved are of various forms and were found in isolation, suggesting that such pendants were attached to a simple lace of some organic material that has not survived.

There are a great many Pompeian examples of necklaces made of simple glass paste, which was much cheaper and therefore more common. They all consist of beads of more or less spherical shape, turquoise in color and decorated with ribbing. Evidently, such necklaces, like modern costume jewelry, gave women an affordable way to enhance their appearance with a natural adornment that was particularly dear to them.

"And, to display yet more riches, [Trimalchio] uncovered his right arm adorned with a gold

Long necklace with wheel-shaped clasp, detail (see p. 55, fig. 19). Herculaneum.

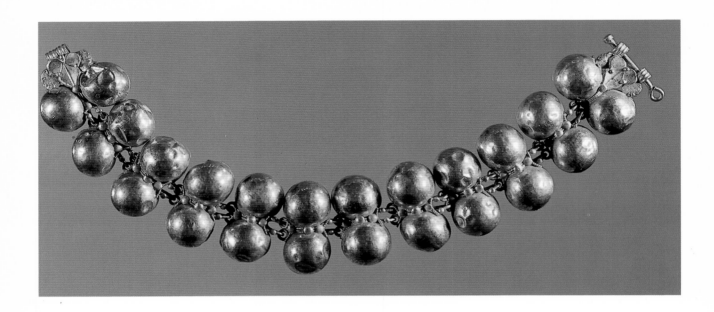

bracelet and an ivory armlet with shining lamina" (Petronius, *Satyricon* XXXII).

Although bracelets were worn by men, they were the prerogative of women, who displayed them on their arms, wrists, and even ankles, in which case they were called *periscelides*, while the others had the generic name of *armilla* (from *armus*, or arm). They came in silver, ivory, amber, and, most commonly, gold. To judge from the archaeological evidence from the Vesuvian area, the most popular type of bracelets took the shape of a serpent or had two serpent's heads facing one another. This model has ancient precedents and owes its popularity to the natural way a serpent's body might coil around the arm as well as to the religious and apotropaic significance of the reptile. Snakes were considered a symbol of fertility and were associated with Isis and Dionysus, as well as with such health divinities as Asclepius and Hygeia. Hemispherical bracelets were almost as popular. They consisted of a sequence of dome-shaped pieces, which might be paired, fashioned in gold sheet, and hooked together. Like segment-shaped earrings, these are considered to be an original creation of the Roman goldsmiths. Another type of bracelet utilizes bezels, which might be smooth, incised with decoration, or embossed. The bracelets decorated with gems seem to have been somewhat less common; notable examples come

Gold "hemispherical" type bracelet (see pp. 57–58, fig. 27).
Pompeii.

from Oplontis. Their singular beauty derives entirely from the chromatic contrast between gold and emerald green.

Now we come to the ring, which was by far the most common article of jewelry and has been conserved in the greatest quantities. It was not an exclusively female prerogative, although its use and abuse were often criticized (as for example by Seneca, *Naturales quaestiones* VII. 31.2) and derided: "who's that curly-headed kid that's always clinging to your wife . . . with a ring on every finger and not a hair on his legs?" (Martial, *Epigrams* V.61). And again, alluding to a character's contradictory tight-fistedness. "Charinus wears six rings on each finger and never takes them off, he doesn't take them off at night and he doesn't even take them off to wash, and you know why? He hasn't got a box to keep them in!" (Martial, *Epigrams* XI.59). However, they were probably more often worn by women, at first with a predominately symbolic value (as engagement or wedding rings). Although increasingly worn for sheer adornment, certain rings retained an important functional aspect. Such rings were used as seals, to "sign" personal writings, as this Pompeian inscription poetically records: "Just for an hour I wish I could be the gem on this ring, to give you the kisses I've planted on it when you moisten it with your mouth to set the seal" (*Corpus Inscriptionum Latinarum* X.10241). The inscription may in fact be a reminiscence of a charmingly witty poem by Ovid, who envies the ring he has sent as a gift to his darling: "O ring that will encircle my fair darling's finger . . . go, welcome gift; . . . o that I might turn myself into my gifts. . . . Then if I wanted to touch my woman's breast, I'd slip from her fingers and fall on her chest. . . . To be able to sign secret letters without the wax sticking to the dry gem, I'd first touch the lovely girl's moist lips" (Ovid, *Amores* II.15).

We also find among the various types of rings one already seen among the bracelets, in the shape of serpent's body or two serpent's heads facing one another fashioned in silver or gold. There are also very sim-

Ring in gold and emerald (see p. 60, fig. 37). Pompeii.

ple rings consisting solely of gold wire or a band with a smooth or engraved bezel. The most common rings of all were gold ones adorned with a gem, which might be smooth or might display intaglio. The gem was most likely to be carnelian, at least based on the examples conserved in the neighborhood of Vesuvius, possibly because carnelian was cheaper than emeralds, garnets, or topazes, which were also used: "My Stella, o Severus, wears sardonyx, emeralds, diamonds and jaspers on every finger" (Martial, *Epigrams* V.11). However, the great popularity of carnelian was also due to the fact that, according to Pliny, it was better suited than other stones to intaglio and made a better seal because wax does not stick to it (*Natural History* XXXVII.30–31). A few rings were made of iron or bronze; usually, they were decorated with carnelian or glass paste.

Popularity and Parures

So far we have presented a rapid overview of the jewelry most in vogue in the early Imperial Age, drawing on both the evidence of the ancient authors and the material yielded by Pompeii itself. Next let us consider the popularity of jewelry made of precious materials and discuss the composition of a representative set, or parure. Here the evidence offered by the Vesuvius area obviously takes on great importance—although, all things considered, perhaps not quite as much as one might have expected.

In addition to the previously mentioned—and often quoted—literary sources, which seem to refer primarily to aspects of society that had some particularity (people whose extraordinary wealth or wildly extravagant behavior invited satiric barbs), such as should be examined case by case, we also have archaeological sources. The evidence yielded by excavation falls into two basic categories of finds: objects retrieved from dwellings and those retrieved from burial sites, where the objects the deceased had used in life were buried as grave goods. However, the latter category does not serve our purpose quite as well, because the

Ring in gold and glass paste with two snake's heads facing one another (see p. 59, fig. 31). Oplontis.

body itself was bedecked with the jewelry, which could thus amount to only as much as might reasonably be worn at one time. For example, no more than one necklace or pair of earrings would be present. The jewelry found in a burial site would therefore not reflect an entire set, only the items used to adorn the deceased. And then, of course, kith and kin no doubt would have wanted to preserve some personal effects of their loved one, which may well have checked any idea of consigning all jewelry to the tomb. In the case of dwellings, however, we must again recall the truly exceptional circumstances of Pompeii, which, unlike so many other cities, was not gradually abandoned by a population whose members were able to take their belongings with them. Within just a few hours, houses were overwhelmed while still pulsing with life and were buried. Some residents probably managed to escape in time to take refuge elsewhere, but many victims of the eruption were found still wearing or clutching their most precious belongings, including—quite naturally— their jewelry. In other cases, panic or other circumstances left victims no chance to gather their belongings, and a number of houses yielded real treasure troves, sometimes stashed in family coffers or caskets. These unfortunate circumstances provide evidence of the household property and the opportunity to compare the worth of valuable items with the overall wealth shown by the house. Thus we can appreciate the extraordinary documentary value represented by the cities of Vesuvius.

Iconographical evidence offered by sculpture and, above all, paintings conserved in these cities is an aspect well worth considering. However, although study is well underway in this field, we are still waiting for the results.

In our survey of the various types of jewelry we also considered their relative occurrence, which must have reflected not only fashion but also cost. On the whole, we may say that of the materials used to craft jewelry, gold takes a very decided first place over silver or the baser metals, such as bronze and

Earrings in gold and glass (see p. 54, fig. 16). Pompeii.

iron. The women of ancient Pompeii do not seem to have taken much interest in costume jewelry: if it was to be a jewel, it had to be a real one. The only exception was, as we have seen, the large number of glass-paste necklaces: evidently necklaces in precious materials were too costly for the purse of the average citizen of Pompeii or Herculaneum. so imitations just had to do.

Regarding the composition of a typical set of jewelry, the data that can be gleaned from archeological evidence conform with what we would expect, leading to a fairly obvious result. Analysis of the quantities of various items of jewelry documented with excavation reveals that the most numerous were, in decreasing order, rings, earrings, bracelets, and necklaces. By examining the combinations of items found with particular individuals, we have learned that a ring plus earrings is the most popular combination, along with a ring plus a bracelet. Therefore, the average parure, excluding cases of particular wealth, would have consisted of a ring (or possibly a variety of rings), earrings, and a bracelet. Necklaces are rarely found, although, as we have seen, they did occur made of certain poor materials.

It would be very interesting for the purposes of a socio-economic survey to be able to determine the relative occurrence of jewelry crafted with precious materials among people living in the Vesuvian region: how many of them possessed jewels, and in what quantities? In this case, however, we find the area sadly lacking, rich as it is in data on the everyday life of Romans in the first century A.D. The fundamental item of data lacking is the number of people living on the sites in this region; various calculations have led to

Painting of the so-called Sappho. Pompeii. Museo Archeologico Nazionale. Naples. inv. 9084.

often widely divergent outcomes. Nor can we tell how many people were left in the cities and how many made successful escapes, taking their belongings away with them. Thus we are faced with an overall quantity of jewelry of which some items, but not all, are attributable to single individuals or dwellings—but we do not know what proportion of the population objects can be assigned to. Moreover, to calculate a precise percentage of an item's incidence we would also have to know the number of free adult women in the population because, generally speaking, jewelry could not be possessed by slaves. The only solution, therefore, seems to rest with the jewelry associated with particular individuals: in other words, how many of the bodies found had jewelry on them, in what quantity, and of what types? The question has been addressed in a recent study showing that, of the bodies found, about 10 percent had jewelry with them, in quite modest quantities in most cases. It would seem that jewelry—at least in this region—was not very common, and that the frequent moralizing and satirical tirades launched by the writers of the time must have been somewhat exaggerated or, at least, applicable only to Rome or the upper classes.

Thus the cities in the region of Vesuvius, including Herculaneum—generally considered more prosperous and refined than Pompeii—can be seen in their true light. Though they were not simply plain and provincial, they were by no means leading cities in Roman Italy of the first century A.D. It is to this economic and social level that the unique, invaluable evidence they offer is to be attributed.

Catalogue of Ornaments

1. Diadem

Inv. P 7654. Gold and ornamental pearls. Pompeii, Villa Imperiale. Length: 7.7 cm; height: 3.3 cm.

The jewel consists of a gold sheet displaying an openwork wave motif. Inserted in it are three oval bezels in sheet gold, each containing a large pearl. Welded to the ends are two small rings of knurled wire, by which the jewel could be attached to the wearer's head, possibly with a slender ribbon.

The wave motif was quite common; in this case it might be an evocative allusion to the marine environment represented by the pearls.

In use in the first century A.D.

2. Hairpin

Inv. P 6031. Silver. Pompeii, House of Epidius Primus (I.8.13-14). Length: 13.2 cm.

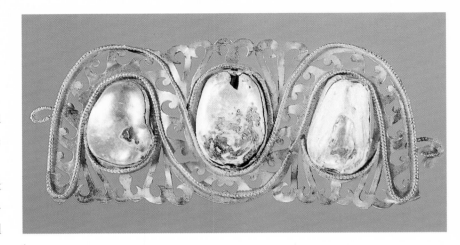

1

2

The head of this hairpin consists of a Corinthian capital surmounted by a naked, winged cupid resting with his right hand on an upturned torch.

In use in the first century A.D.

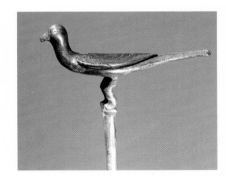

3

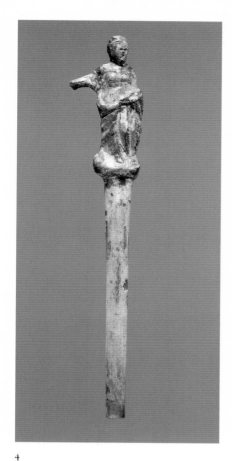

4

3. Hairpin

Inv. P 7028. Silver. Pompeii, House of the Indian Statuette (I.8.5). Length: 13.5 cm.

The head of this hairpin represents a bird, possibly a dove; minute incisions executed with great care create the effect of plumage. Hairpins with bird-shaped heads can be found in all periods, from the Bronze Age to Roman times. The dove is the bird sacred to Venus and thus appropriate for female adornment.

In use in the first century A.D.

4. Hairpin

Inv. Op 4625. Silver. Oplontis, Villa of Crassius Tertius. Length: 6.6 cm.

The head of this hairpin is in the shape of a standing female figure dressed in a long tunic and mantle who may be identified as Venus—a truly appropriate divinity for a woman's toilet item, figured on hairpin heads in all ages.

In use in the first century A.D.

5. Hairpin

Inv. P 6028. Gold and amber. Pompeii, House of Epidius Primus (I.8.13-14). Length: 13.7 cm.

The head consists of a *krater* (a bowl for mixing wine with water) whose body is of sheet gold and whose handles are of knurled wire. An amber stone fills the vessel's mouth. The head ends in a beaded collar, into which the hairpin's shaft has been inserted.

A similar example was found in Pompeii in the House of Menander.

In use in the first century A.D.

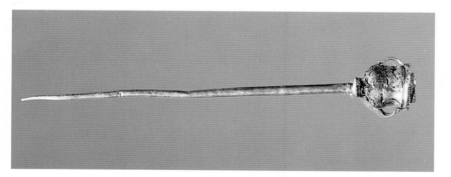

5

6. Earrings

Inv. P 7974. Gold. Pompeii, V.4, by some skeletons. Height: 2.7–2.8 cm; width: 2.4 cm.

A pair of earrings in smooth sheet-gold shaped in the form of a sphere segment, open at the back. As always for this type of earring, the hook is in smooth, S-shaped wire. A gold dome conceals the welding between the hook and body of the earring.

Among the most common type of earring found in the Vesuvius region and in the Roman world in the first and second centuries A.D.

7. Earrings

Inv. Op 2996. Gold. Oplontis, Villa of Crassius Tertius. Height: 2.9–3.1 cm; width: 2.3 cm.

A pair of sphere-segment earrings like the previous pair, but with the body decorated with close-embossed dotting imitating the more refined technique of granulation.

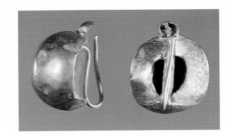

6

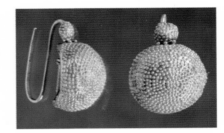

7

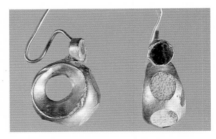

8

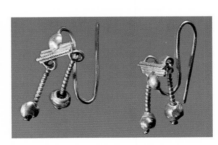

9

Although less common than the simple smooth-body type, this type of earring is well known in the Vesuvius area.

In use in the first century A.D.

8. Earrings

Inv. P 12518. Gold and glass. Pompeii, north side of Porta Marina. Max. diam: 2.35 cm; max. thickness: 1.4 cm.

The body of the jewel, in smooth sheet-gold, is shaped in the form of a circular, hollow crown of decreasing thickness. Three oval bezels, each containing a white glass bead, are cut into the broader part facing outward. A circular bezel in sheet-gold containing a green bead of glass has been welded at the point where the S-shaped hook is attached.

In use in the first century A.D.

9. Earrings

Inv. P 13403. Gold and pearls. Pompeii, western insula, House of Fabius Rufus. Height: 3.1 cm; width: 1.4 cm.

A pair of "bar" earrings consisting of a small bar from the ends of which hang two knurled wires bearing pearls.

This was one of the most popular types of earrings among the women of the Roman world between the first and early third centuries A.D.

10. Earrings

Inv. Op 3407. Gold and pearls. Oplontis. Villa of Crassius Tertius. Height: 3.8 cm; width: ca. 1.6 cm. Similar to the previous type, but with smooth bar and wires; the pearls are particularly notable for their size and perfectly spherical form.

11. Earrings

Inv. e 3654. Gold and pearls. Herculaneum, vault 8 on the ancient marina, between two skeletons. Height: 3 cm.

Ancient sources call this type of earring a *stalagmium*. Consists of an S-shaped hook and simple pendant of smooth wire from which a pearl hangs.

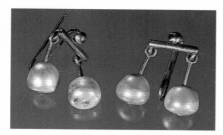

10

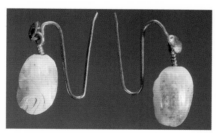

11

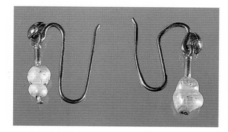

12

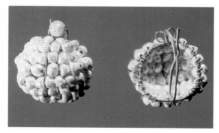

13

Fairly common in the Vesuvius area and, more generally, in the Roman world.

In use in the first century A.D.

12. Earrings

Inv. Op 2997. Gold and mother-of-pearl. Oplontis. Villa of Crassius Tertius. Height: 2.4–2.6 cm. Similar to the previous model, except here the pearl has been replaced with a mother-of-pearl shell, possibly for the sake of economy.

In use in the first century A.D.

13. Earrings

Inv. P 11071. Gold and beads. Pompeii. House of the Arches (I.17.4). Intact. Max. diam: 2.5 cm. This type is called a basket earring on account of its shape. The body consists of a hemisphere with beads inserted. Although not found in great quantities, the type is well known at Pompeii; it has not been found at Herculaneum, however.

In use in the first century A.D.

14. Earrings

Inv. Op 3326. Gold and quartz. Oplontis. Intact. Max. diam: 3.5 cm.

In this rare variant of a basket earring, the body of the earring consists of 26 small sheet-gold bezels welded together to form a hemispherical shape into which quartzes have been inserted.

In use in the first century A.D.

15. Earrings

Inv. E 3260. Gold. Herculaneum, one of the vaults of the ancient marina. 2.8 x 2.4 cm.

Yet another variant of the basket earring; here the elliptical body is formed by a net of gold threads. As usual, the hook is S-shaped.

This might be a normal basket model that has lost its pearls, leaving only the structure.

In use in the first century A.D.

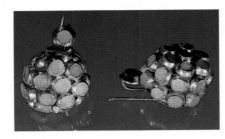

14

15

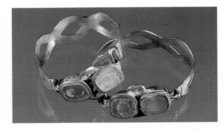

16

17

16. Earrings

Inv. P 7664. Gold and glass. Pompeii, Villa Imperiale. Intact. Max. diam: 4.1 cm.

Sheet-gold showing openwork, to which are welded a pair of bezels, each containing a glass bead. A banded ring is welded to the end bezel, and the clasp's hook was inserted in it.

There do not appear to have been any similar Roman examples, but the type bears a marked resemblance to earrings dating to the late sixth century B.C. from the Sindos necropolis in Macedonia.

17. Earrings

Inv. P 2681. Gold. Pompeii, tavern of Zosimus (III.4). 3.1 x 2.3 cm.

Very fine, smooth sheet-gold, oval in shape, one end of which is perforated to accept the S-shaped hook. Examples similar to this rather rare type are more frequent in the second century A.D. than in the first century.

18. Necklace

Inv. P 5413. Gold. Pompeii, House of the Smith (I.10.7). Intact. Length: 44.5 cm.

Choker with snake clasp. The pendant consists of a statuette of Isis Fortuna with rudder and horn of plenty.

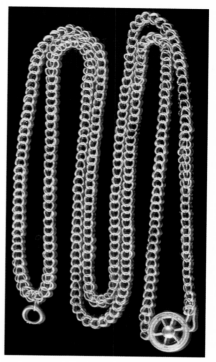

19

In use in the first century A.D.

19. Necklace

Inv. E 3646. Gold. Herculaneum, by two skeletons in vault 8 on the ancient marina. Length: 173 cm. Long necklace with wheel-shaped clasp and crescent pendant; may have been worn across the chest, bandolier-style.

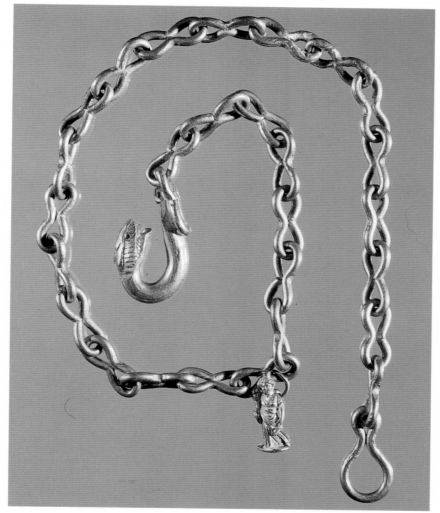

18

Resting on the shoulders and crossing the chest and back, it would hang down to the hips.
In use in the first century A.D.

20. *Necklace*

Inv. Op 3307. Gold and emeralds. Oplontis. Length: 34.9 cm.
This choker-type necklace consists of gold beads alternating with emerald beads. The pendant is a small crescent moon.

21. *Necklace*

Inv. P 8608. Gold and emerald. Pompeii, House of Julia Felix (II.4). Length: 36.3 cm.
Fine gold chain, beads alternating with links. The pendant is in the shape of a crescent moon, the clasp adorned with a quadrangular bezel containing an uncut emerald.
In use in the first century A.D.

22. *Necklace*

Inv. E 3098. Crystal. Herculaneum, by two skeletons in vault 12 on the ancient marina.
The necklace consists of 35 crystal beads of various shapes and sizes.
It is a very simple type of necklace, and yet very uncommon.
In use in the first century A.D.

20

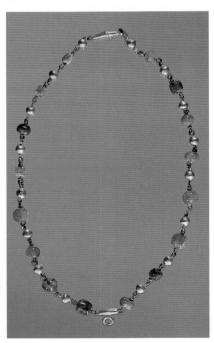

21

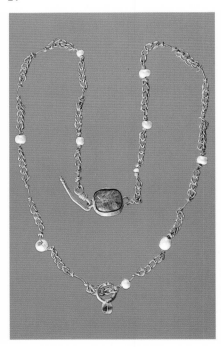

22

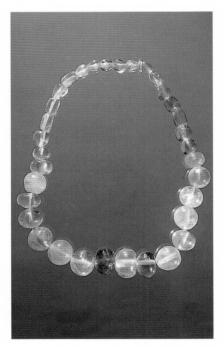

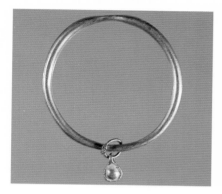

23

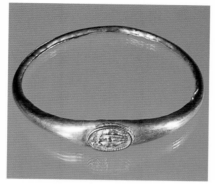

24

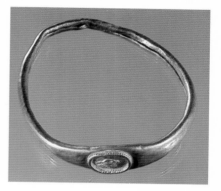

25

23. Bracelet

Inv. P 4492. Gold. Pompeii. Villa of the Mysteries. Intact. Diam: 7.6 cm.

One of the simplest types of bracelet: consists of a solid, smooth rod with incised bezel. The incision shows one of the commonest motifs—a palm branch. The bracelet is enhanced with a "bulla" pendant (a type children would wear hanging from the neck) fashioned in gold sheet.

In use in the first century A.D.

24. Bracelet

Inv. P 23878. Gold. Pompeii, House of Julius Polybius (IX.13.3). Diam: 6.4 cm.

The rod is ribbon-shaped with the edges folding inward and increasing in breadth toward the bezel, which shows embossed decoration. The three Graces are depicted according to the iconography customary since the Hellenistic period.

In use in the first century A.D.

25. Bracelet

Inv. Op 3397. Gold. Oplontis. Diam: 7.9 cm.

Typologically, this bracelet resembles the previous example. Embossed on the bezel is a depiction of "Aphrodite at her Bath": the goddess is in the act of removing her shoes. This iconographic subject enjoyed considerable popularity in various artistic genres from the late Hellenistic period.

In use in the first century A.D.

26. Bracelet

Inv. Op 3312. Gold and emerald. Oplontis. Diam: 9.6 cm.

Bracelet with hollow gold band in which an emerald is set. This very simple jewel derives its beauty from the chromatic contrast between the vivid green of the emerald and the warm yellow of the gold.

In use in the first century A.D.

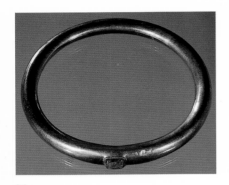

26

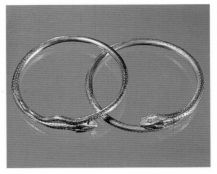

28

27. Bracelets

Inv. P 10759 A-B. Gold. Pompeii, House of Venus in Bikini (I.11.6). Lenght 24 cm.

Pair of hemispherical bracelets, one of the most common types in the first century A.D.. A pair of gold hemispheres in gold are con-nected with small hooks. The end pair are decorated with a vine-leaf fashioned with embossed gold.

In use in the first century A.D.

28. Bracelets

Inv. E 3655–3656. Gold and silver. Herculaneum, on a skeleton in vault 8 on the ancient marina. Diam: 7.2–7.4 cm.

The band is shaped like a snake, the eyes being made of small sil-ver globes. This is one of the most characteristic and popular types of bracelet in the ancient world, doubtless because of the religious significance attributed to the ser-pent as a symbol of fertility.

In use in the first century A.D.

29. Bracelets

Inv. E 3061–3062. Gold and glass paste. Herculaneum, the ancient marina. Diam: 9–9.3 cm.

Again we find the serpent

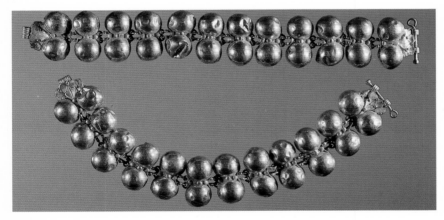

27

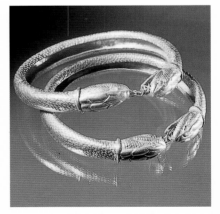

29

motif, this time with two heads facing one another. These examples show extremely refined crafting.

In use in the first century A.D.

30. Ring

Inv. P 7660. Gold. Pompeii, Villa Imperiale. Intact. Diam: 2 cm.

In the shape of a serpent wrapped in coils, this ring is one of the most characteristic types among those in circulation in the early Imperial Age. It is found in both gold and silver.

In use in the first century A.D.

31. Ring

Inv. Op 3403. Gold and glass paste. Oplontis. Diam: 2.4 cm.

The ring type with two heads facing one another is the commonest variant on the snake-ring model. The eyes may be represented with small glass-paste globes, as in this case, or with gems.

In use in the first century A.D.

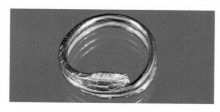

30

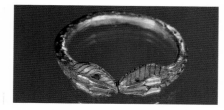

31

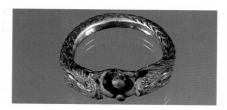

32

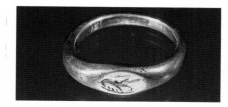

33

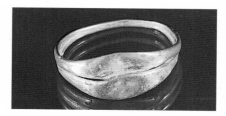

34

32. Ring

Inv. P 15497. Silver. Pompeii, by the body of a dead girl outside the Nola gate. Diam: 2.7 cm.

Silver ring displaying two serpent's heads facing one another with a *patera* (dish) in their jaws.

In use in the first century A.D.

33. Ring

Inv. Op 2999. Gold. Oplontis. Diam: 2.3 cm.

Ring with solid body. Engraved on the bezel is a raven on a laurel branch, alluding to the god Apollo. In the early Imperial Age, rings with smooth or engraved bezels were extremely common, second in popularity only to rings with gems. Among the subjects engraved, animals are particularly frequent.

In use in the first century A.D.

34. Ring

Inv. P 8961. Gold. Pompeii, House of Julia Felix (II.4). Diam: 1.8 cm.

The thin, band-shaped bar is divided into two smooth, coupled bezels. This somewhat uncommon type of ring may display engraved bezels and is known between the first century B.C. and the first century A.D. In use in the first century A.D.

35. Ring

Inv. Op 3398. Gold. Oplontis. Diam: 1.8 cm.

The ring is decorated with the mask of an actor in a "New Comedy" welded to the band. Although relatively uncommon, this type of ring, with small sculpture-like decoration, is well known in the early Imperial Age.

In use in the first century A.D.

36. Ring

Inv. Op 3320. Gold and pearl. Oplontis. Diam: 2.1 cm.

The band consists of knurled wire with slender smooth ends where a pearl is inserted. This type of ring is well represented among Roman

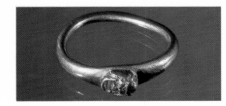
35

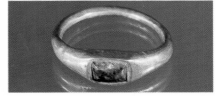
36

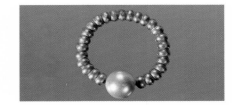
37

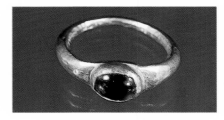
38

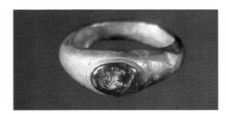
39

jewelry of the first century A.D. In use in the first century A.D.

37. Ring

Inv. P 4884. Gold and emerald. Pompeii, House of Menander (I.10.4). Diam: 2.3 cm.

Ring fashioned with a thin hollow band of sheet-gold with quadrangular bezel holding a smooth emerald. The most common type of ring has a gem, either smooth or displaying intaglio. Of the smooth gems, the emerald is found most frequently. In use in the first century A.D.

38. Ring

Inv. P 14098 C. Gold and garnet. Pompeii, western insula, House of Fabius Rufus. Diam: 1.9 cm.

Ring consisting of a solid band widening toward the oval bezel, which stands out from the band and encloses a garnet with smooth convex surface. Smooth or engraved, garnets were frequently used for rings. In use in the first century A.D.

39. Ring

Inv. P 8607. Gold and carnelian. Pompeii. House of Julia Felix (II.4), by the skeleton of a woman. Diam: 2 cm.

Ring with carnelian showing a convex surface and, in intaglio, the head and top of the bust of Mercury.

In use in the first century A.D.

40. Ring

Inv. P 5415. Gold and garnet. Pompeii. House of the Smith (I.10.7), in a cupboard. Diam: 2.1 cm.

The large oval bezel contains a garnet whose convex surface displays in intaglio a running dog—a very popular gem motif in the first century A.D.

41. Ring

Inv. P 2678. Gold and white chalcedony. Pompeii. III.4. Diam: 2 cm.
Ring with hollow gold band that widens toward the large oval bezel containing a flat-surfaced chal-

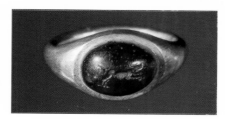

40

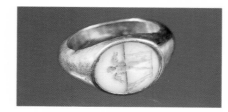

41

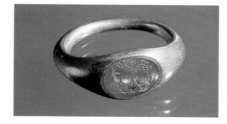

42

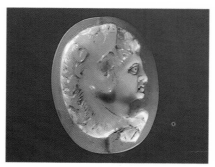

43

cedony. Engraved with a cupid displaying open wings.

In use in the first century A.D.

42. Ring

Inv. Op 3315. Gold and chromo-chalcedony. Oplontis. Diam: 1.9 cm.
Ring with an intaglio gem depicting a bull grazing in the background of a large tree. Animal depictions, frequent in glyptic work, derive from Roman Hellenistic iconography.
In use in the first century A.D.

43. Chalcedony

Inv. P 39589. Agate chalcedony. Pompeii. House of the Gemmarius (II.9.2). 2.23 x 2.43 cm.
Exploiting the various colors of the gem according to the cameo technique, this piece presents the bust of Alexander the Great sculpted as Hercules, his head covered with a lion's skin. Based on its stylistic features, the gem can be dated to the period of Nero through the Flavians (A.D. 54–79).

44

45

46

44. Carnelian

Inv. P 39587. Carnelian. Pompeii,
House of the Gemmarius (II.9.2).
2.42 x 1.46 cm.

On the gem (which was probably
meant to be set on a ring), an
intaglio decoration depicts the
slaying of the fantastic monster,
the Chimaera, by the Greek hero
Bellerophon, shown riding his
winged horse, Pegasus.

First century A.D.

45. Corundum

Inv. P 39597. Blue corundum.
Pompeii, House of the Gemmarius
(II.9.2). 1.23 x 2.17 cm.

This exquisite gem shows in finely
crafted intaglio a winged seahorse
characterized by a long tail with
two opposite fins—a very popular
subject in Hellenistic and Roman
glyptic work.

First century B.C. to first
century A.D.

46. Carnelian

Inv. P 39596. Carnelian. Pompeii,
House of the Gemmarius (II.9.2).
1.21 x 0.94 cm.

Probably intended to be set on
a ring, the gem shows in
intaglio a mighty lion ridden by
a male figure armed with
shield, helmet, and spear.

First century A.D.

D'AMBROSIO, A., AND E. DE CAROLIS. *I monili dall'area vesuviana*. Rome, 1997.

BARINI, C. *Ornatus muliebris. I gioielli e le antiche Romane*. Torino, 1958.

BÉAL, J. C. *Catalogue des objets de tabletterie du Musée de la civilisation romaine de Lyon*. Lyon, 1983.

BIANCHI, C. *Spilloni in osso di età romana. Problematiche generali e rinvenimenti in Lombardia*. Milan, 1995.

BLIQUEZ, L. J. *Roman Surgical Instruments and Other Minor Objects in the National Museum of Naples*. Mainz, 1994.

DAREMBERG, C., and E. SAGLIO, eds. *Dictionnaire des antiquités grecques et romaines*. 5 vols. Paris, 1877–1919.

GIORDANO, C., AND A. CASALE. *Profumi unguenti e acconciature in Pompeii antica*. Rome, 1992.

MATTINGLY, D. J. "Paintings, Presses and Perfumes: Production at Pompeii," in *Oxford Journal of Archaeology*, 9, 1990, pp. 71–90.

PIRZIO BIROLI STEFANELLI, L. *L'Oro dei Romani. Gioielli di età imperiale*. Rome, 1992.

ROSSI-OSMIDA, G., ET AL. *Aphrodite's Scents*. Exhibition catalogue. Trento, 1986.

VIRGILI, P. *Acconciature e maquillage*. Rome, 1989.

VIRGILI, P., AND C. VIOLA. *Bellezza e Seduzione nella Roma Imperiale*. Catalogo della mostra. Rome, 1990.

BIBLIOGRAPHY

Amorino	Baby winged figure (cupid).
Armilla	Bracelet.
Asclepius	God of medicine.
Auriscalpium	Small stick used for cleaning the ears.
Bulla	Medallion-shaped container enclosing an amulet, hung round the neck of children.
Calamistrum	Cylindrical hairdressing tool that was heated and then used to curl locks of hair.
Chimaera	Monster in Greek mythology, with a lion's head, a second, goat's head on the back, and a serpent's tail.
Crotalia	Earrings with pearl pendants.
Dentiscalpium	Stick used for cleaning the teeth.
Filigree	Decorative technique reproducing ornamental motifs by welding fine gold threads to the ornament's surface.
Gemmarius	Intaglio craftsman or jewel merchant.
Graces	The three graces (Euphrosyne, Thalia, and Aglaia) were the divinities of beauty and joy.
Granulation	Decorative technique reproducing ornamental motifs by welding tiny grains of gold to the ornament's surface.
Hygeia	Daughter of Asclepius, goddess of health.
Knurled	Beaded.
Leontè	Skin and skull of the Nemean lion killed by Hercules.
Lunula	Necklace pendant in the shape of a crescent moon; used as an amulet for girls.
Macellum	Covered market, mainly for the sale of meat and fish.
Ornatrix	A slave who was expert in hairdressing.
Periscelides	Ornamental rings in precious material, worn on the ankles.
Pyx	Cylindrical container for small objects.

GLOSSARY

Stalagmium Earring with pearl or mother-of-pearl pendant.

Unguentarium Small jar for ointments or perfumes.

Cato
On Agriculture (XXXIX)

Catullus
Poems (13.10-14)
Poems (39.23-25)

Juvenal
Satires (VI.457-459)
Satires (VI.461-473)

Martial
Epigrams (I.87)
Epigrams (III.55)
Epigrams (V.11)
Epigrams (V.61)
Epigrams (VI.12)
Epigrams (VI.55)
Epigrams (X.38)
Epigrams (XI.59)
Epigrams (XI.1.23)
Epigrams XIV, Apophoreta, 22
Epigrams XIV, Apophoreta, 24
Epigrams XIV, Apophoreta, 25
Epigrams XIV, Apophoreta, 27

Ovid
Art of Love (III.129-131)
Art of Love (III.133-152)
Art of Love (III.135-136)
Art of Love (III.163-164)
Art of Love (III.193-199)
Art of Love (III.194)
Art of Love (III.200-204)

LIST OF AUTHORS CITED IN THE TEXT

Art of Love (III.209-218)
Art of Love (III.236-240)
Art of Love (III.243-246)
Amores (I.14)
Amores (II.15)

Petronius
Satyricon (LXVII)
Satyricon (LXXIV)
Satyricon (CX)
Satyricon (XXXII)

Pliny the Elder
Natural History (IX.35)
Natural History (IX.117 ff.)
Natural History (XII.84)
Natural History (XIII.2-3)
Natural History (XIII.20)
Natural History (XXVIII)
Natural History (XXXVII.16)
Natural History (XXXVII.30-31)

Propertius
Elegies (II.18b)

Seneca
On Benefits (VII.9.4)
Epistles (86.12)
Problems of Science (VII.31.2)

Tacitus
Annals (III.53)

Ulpian
Digest (XXXIV, 2.25, 10)